IMAGES
of America

CINCINNATI'S
OVER-THE-RHINE

D1452046

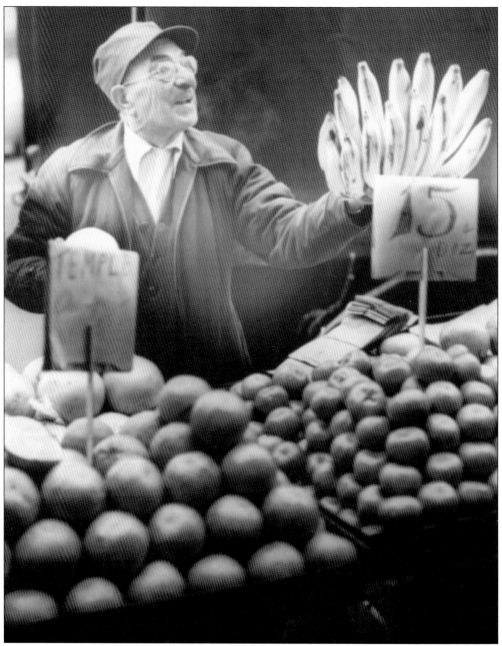

A landmark of Over-the-Rhine for over a century, Findlay Market still attracts shoppers every Wednesday, Friday, and Saturday to its stalls of fresh produce, meats and cheeses, and baked goods, offering an Old World touch to an urban setting. This 1950s image shows the produce offered by one seller. (Photograph by Jack Klumpe.)

IMAGES
of America

CINCINNATI'S OVER-THE-RHINE

Kevin Grace and Tom White

ARCADIA

Published by Arcadia Publishing
Charleston SC, Chicago IL, Portsmouth NH, San Francisco CA

Printed in the United States of America

Library of Congress Catalog Card Number: 2003106977

For all general information contact Arcadia Publishing at:
Telephone 843-853-2070
Fax 843-853-0044
E-mail sales@arcadiapublishing.com
For customer service and orders:
Toll-Free 1-888-313-2665

Visit us on the Internet at www.arcadiapublishing.com

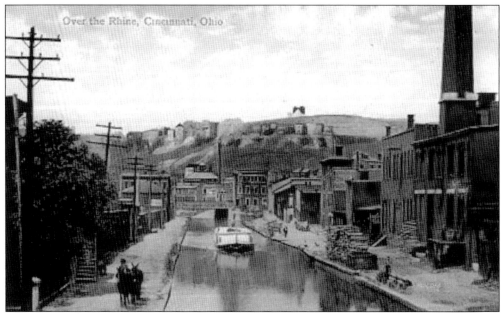

The Miami & Erie Canal was constructed in 1825, and for almost a century it separated downtown from the neighborhood to the north. In a joking reference to Germany's Rhine River, the area came to be known as "Over-the-Rhine" because of the concentration of German immigrants who settled there. The canal moved produce and goods from central Ohio down through Cincinnati, but by 1877 it was officially abandoned for transport.

CONTENTS

ACKNOWLEDGMENTS

For help in so many ways, we thank Jymi Bolden, Suzanne Finck, Gene Goldschmidt, Steve Gowler, Greg Hand, Jon Hughes, Sean Hughes, Maria Kreppel, Katherine Lindner, Joan Meister, Brittany Morgan, the late Danny Ransohoff, and Don Heinrich Tolzmann. Thanks also to Melissa Fitz and Jeffrey Ruetsche at Arcadia for their encouragement and guidance and especially to Jack Klumpe for allowing us to sample his documentation of an era in local history.

To my wife Michelle, with gratitude and love as we celebrate our thirtieth wedding anniversary, and to our daughter Anna, for making the last twelve of those years so much fun.

T.W.

Thanks to Joan and to the fabulous five—Lily, Bonnie, Courtney, Sean, and Josh—for their indulgence during a year of pictures scattered about in various rooms.

K.G.

INTRODUCTION

There is an old toast to Cincinnati that was printed once on postcards in the early years of the twentieth century, and it says in part:

> Here's to Cincinnati, the Queen of the West,
> A dirty old city, but still nobly blest.
> For it's here that fine arts with the frivolous twine,
> A veritable Deutschland just Over the Rhine . . .
> The kindliest greetings from all whom we meet,
> A good draught of beer every ten or twelve feet.

It's a romantic presentation of the Queen City, steeped in the appreciation of the German influence on the city's history. Indeed, there were Germans among the first settlers in 1788, and by the early 1800s, there were German publications, churches, singing societies, and beer gardens in Cincinnati, just before the great flood of German immigrants in the 1830s that would give rise to Turner athletic organizations, breweries and businesses, and considerable participation in the city's political and civic affairs. In fact, Over-the-Rhine takes its name from the settlement of early German American immigrants in the district of Cincinnati north and east of the Miami & Erie Canal.

But there is a tendency to over-romanticize this history of Over-the-Rhine, playing extensively to the Germanic aspects of its heritage, and seeing the urban area in a "golden age" once and in decline ever since. It is misleading to view the neighborhood in this way. The German-American period is certainly important, and it has contributed much to the physical, architectural nature of its streets, parks, and buildings, while at the same time providing Cincinnatians with so many cultural ties. But in chronological terms, the German-American settlement represents only a third of its history. There has been so much more meaning in this central part of the urban area to the citizens who have lived and worked there in the last several decades.

Over-the-Rhine is the city's defining neighborhood. For over 150 years, the people, the politics, the economics, and the architecture of Over-the-Rhine have influenced the physical and cultural formation of the rest of the city. The area has always been—and still is—an urban

area of issues and interests. The neighborhood has been a testing ground for city planning and social services. It has been a playground for nightlife in all its facets and for artists seeking workspace and themes that inspire them. And, it has been a battleground of racial politics and gentrification economics, skirmishes between earnest people on both sides of the housing issues that spur development while still servicing the everyday needs of lower income residents.

Traditionally, Over-the-Rhine has been defined as that area bordered by Central Parkway on the west, Broadway and Pendleton Streets on the east, McMicken and West Clifton on the north, and again, Central Parkway to the south. Neighborhoods are more fluid, however, than paved streets indicate. The culture, ethnicity, race, and architecture of Over-the-Rhine flows somewhat beyond these concrete borders into the West End, downtown, and the Fairview Heights-Clifton neighborhood. And so, we have taken a cultural geographical approach in our look at Over-the-Rhine. A demographic profile compiled in 2000 shows that there is now a resident population of 7,638, of which African Americans account for 5,974. Yet there is considerable diversity, including Caucasian, Latino, Asian, and American Indian. More telling is that of 3,594 housing units, 1,667 stand empty, and of the occupied ones, 1,850, or 96 percent, are renter-occupied. These facts reflect what has made Over-the-Rhine an area of tension, poverty, unemployment, and lack of development over the past few decades. Often, the residents have been viewed by politicians, planners, and service agencies as life's in-betweens.

In 2001, a young African-American man by the name of Timothy Thomas was killed in Over-the-Rhine by a policeman. Thomas's death sparked nights of rioting in Cincinnati, led to groups calling for an economic boycott of the city, and a federal appraisal of police-community relations. It has also led to a re-examination of the neighborhood by Cincinnatians and everything it means to the city. That meaning is considerable.

The debates about historic preservation versus development still continue, as do the debates on affordable housing and care for the needy. What has also happened, however, is that Main Street thrives with nightlife. The Reading on Main poetry series is an example of one current community event, as is the BockFest celebration and the Taste of Findlay Market festivities. Miami University professor Thomas Dutton encourages Over-the-Rhine children to compile documentary photographs of their neighborhood. The University of Cincinnati's Art-in-the-Market program, under the direction of Karen Hutzel and Frank Russell, brought in junior high and high school students to create art projects as a healing, restorative process. The Kroger Company completely renovated their grocery store on Vine Street so residents have a clean, affordable place to shop in their own neighborhood. Development of apartments is on the rise.

Over-the-Rhine is more than districts of streets filled with nineteenth century buildings. Real people live, work, shop, and play here. It is a community. It always has been.

One

THE CREATION OF OVER-THE-RHINE:
THE 19TH CENTURY

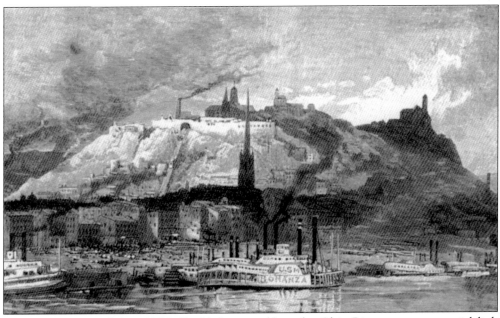

Cincinnati was settled in 1788. Establishing itself on the Ohio River as a commercial link between the East and the expanding Western territories, Cincinnati was an attractive settlement for migrants from the mid-Atlantic states, and as the nineteenth century boomed, for European immigrants.

A large number of the early immigrants to Cincinnati came from Germany. In fact, the first mayor of the city, David Zeigler in 1802, was born in Heidelberg. By 1819, the first German society formed, and the social life of beer gardens began to take hold. By the 1830s, German immigrants were arriving in Cincinnati in a steady stream. After the Miami & Erie Canal was completed in 1831, the recently arrived Germans moved from the city's basin to the largely unsettled district to the north and east of the canal, creating in the process, "Over-the-Rhine." Early homes took on a European flavor of neat brick and frame houses and well-kept gardens along the canal. Saloons and clubs flourished, and German shops proliferated. At the same time, the local and national press began the romanticization of the neighborhood, extolling the German cuisine, family life, music, and the virtues of middle-class hard work. All of this was true, of course, but so was the other aspect, of poor immigrants who also resided there, trying to get by day-to-day.

The community soon became a culturally integrated one of German ethnicity, with all the American divisions of social and economic class. Over-the-Rhine became an enclave that began to exert considerable influence on the rest of the city as factories, churches, breweries, theaters, and small businesses grew.

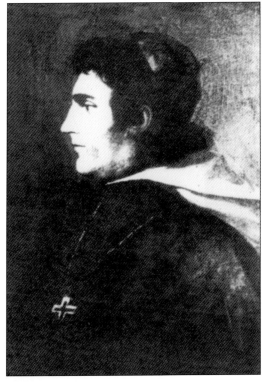

The Right Reverend Edward Fenwick was a Catholic missionary in the Ohio Valley in the 1840s. Appointed bishop for the new province of Ohio, he journeyed to Cincinnati and established the first Catholic Church, St. Patrick's, in what would become Over-the-Rhine.

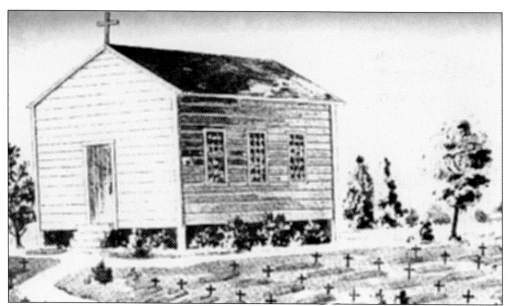

Fenwick's church was built beyond the city limits because Cincinnati was not very welcoming for Catholics. When religious tensions eased, Fenwick moved the church closer to downtown. During the move, the building collapsed into pieces, but Fenwick refused to give it up and had it reassembled in its new location on Sycamore Street.

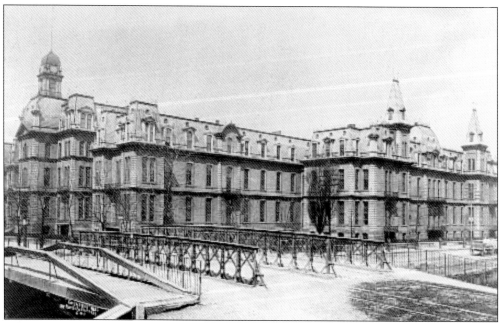

In 1823 Dr. Daniel Drake persuaded the Ohio General Assembly to charter a hospital where students at his Medical College of Ohio could practice what they were being taught in the classroom. Thus the Cincinnati Commercial Hospital and Lunatic Asylum, at Canal and Twelfth Street, became the nation's first teaching hospital. The city purchased the hospital in 1861, and this multi-building complex was completed in 1869.

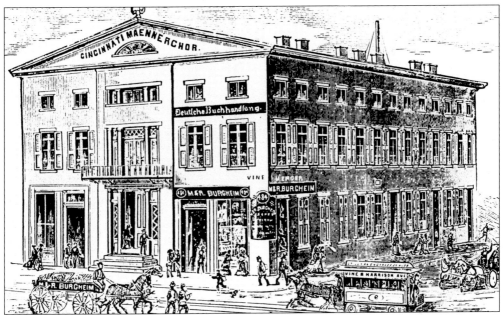

The Cincinnati Maennerchor (men's choir) was created when the Liedertafel, Saengerbund, and Germania singing societies joined forces in 1857. The merger created a large music library and provided the new organization with ample funding. The Maennerchor performed in the building illustrated here until 1879 and later spent $100,000 on an impressive new four-story hall at 1115 Walnut.

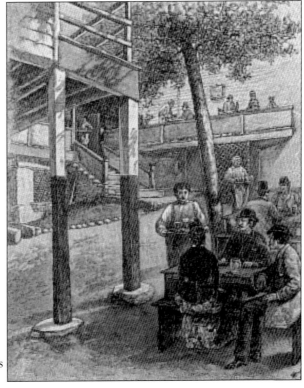

Many Over-the-Rhine drinking establishments had outdoor beer gardens. Although this illustration shows a clientele of adult males, these shady retreats were quite popular with German families as well. Wielert's Café had the largest and most famous of the area's beer gardens. The café building, where political boss George Cox would meet with his lieutenants, still stands at 1408–1410 Vine Street.

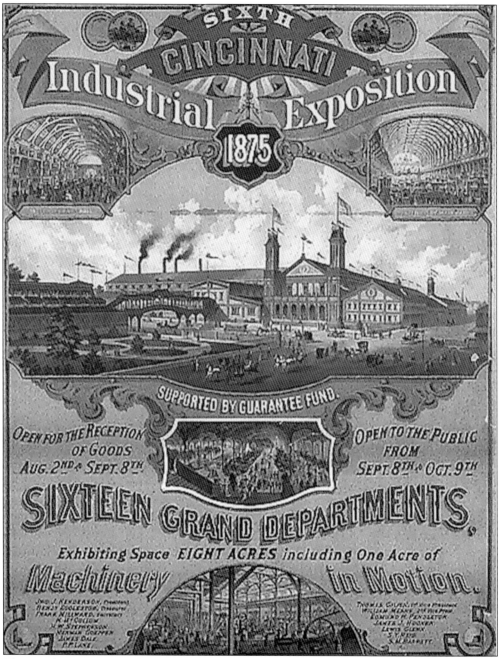

The 1875 Cincinnati Industrial Exposition was the sixth and last to be held in Saengerfest Halle. No event was planned for 1876 so as not to compete with the United States Centennial Exposition, and Saengerfest Halle was demolished in 1877 to make way for the construction of Music Hall, the site of all future industrial expositions in Cincinnati.

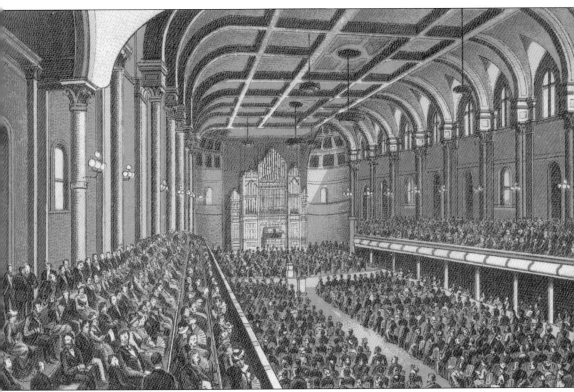

This 1878 view of Music Hall's auditorium bears little resemblance to what today's concertgoer sees. Designed to function as both concert and exposition hall, there was no permanent seating. The entire room was paneled in oiled yellow poplar, which made for excellent acoustics but offered little visual diversity. An extensive 1896 renovation created the elegant configuration known today.

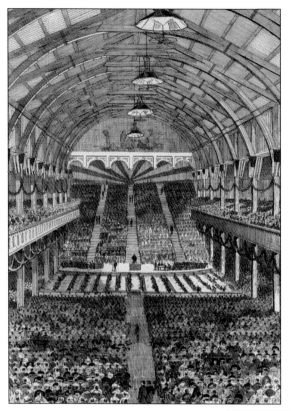

In 1876, the Republican National Convention met in Over-the-Rhine's Exposition Hall to select their candidate for the American presidency. After seven ballots, Cincinnati attorney, congressman, and governor Rutherford B. Hayes was nominated. Hayes had come to Cincinnati from Fremont, Ohio, to practice law. He flourished as an attorney, soon becoming known for voluntarily defending fugitive slaves. In 1856 he helped form the Ohio Republican Party, and this was followed by service in the Civil War and terms as a U.S. congressman and Ohio's governor. The sketch of the convention at Exposition Hall is from a June 15, 1876, report of the convention, showing the hundreds of delegates gathered to vote. After several ballots, one reporter said that "a convention is a mob, at the mercy of impulses and infatuations."

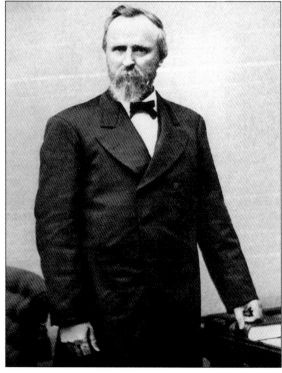

The College of Music of Cincinnati was the brainchild of George Ward Nichols. Nichols lured nationally known conductor Theodore Thomas from New York to head the newly formed college. The school opened in October 1878 with Thomas, a faculty of thirty-one, and more than a hundred students from all parts of the country. Classes met in Music Hall until 1884 when the Odeon, site of these Beethoven's birthday concerts, was built next door.

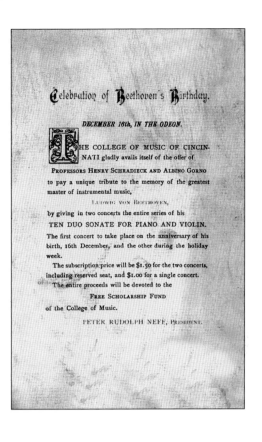

Celebration of Beethoven's Birthday.

DECEMBER 16th, IN THE ODEON.

THE COLLEGE OF MUSIC OF CINCINNATI gladly avails itself of the offer of PROFESSORS HENRY SCHRADIECK AND ALBINO GORNO to pay a unique tribute to the memory of the greatest master of instrumental music,

LUDWIG VON BEETHOVEN,

by giving in two concerts the entire series of his

TEN DUO SONATE FOR PIANO AND VIOLIN.

The first concert to take place on the anniversary of his birth, 16th December, and the other during the holiday week.

The subscription price will be $1.50 for the two concerts, including reserved seat, and $1.00 for a single concert. The entire proceeds will be devoted to the

FREE SCHOLARSHIP FUND

of the College of Music.

PETER RUDOLPH NEFF, PRESIDENT.

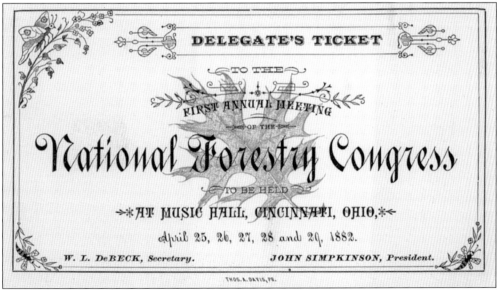

Although Nebraska held the first Arbor Day celebration in 1872, the National Forestry Congress began the national tradition of Arbor Day at this convention at Music Hall in 1882. During the convention, a tree-planting ceremony involving local schoolchildren resulted in Authors' Memorial Grove and Presidential Grove in Eden Park.

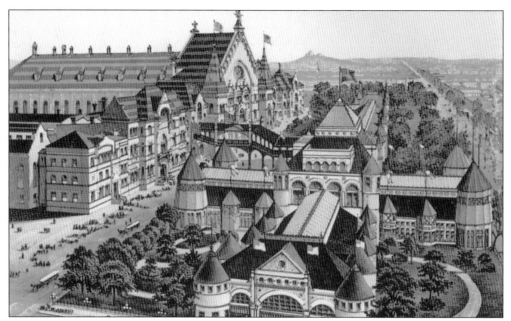

Cincinnati's Centennial Exposition in 1888 was the last and the largest of its grand industrial expositions. The size of this event required the construction of two huge temporary buildings. The cruciform building in the foreground, occupying much of Washington Park, is Horticulture Hall. The second structure, Machinery Hall, straddled the canal behind Music Hall from Twelfth to Fifteenth Streets.

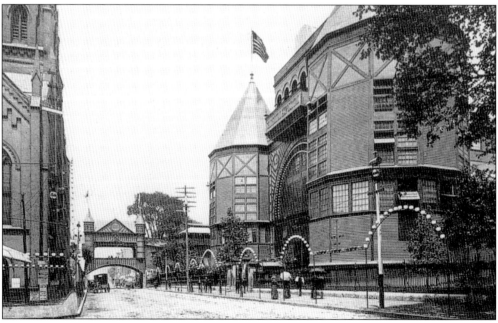

Officially titled the Centennial Exposition of the Ohio Valley and Central States, this spectacle ran from July 4 through November 8, 1888, and attracted an estimated one million visitors. One of the showcased technologies was electric lighting, still a novelty in Cincinnati. Note the lighted arches lining Elm Street in this photograph.

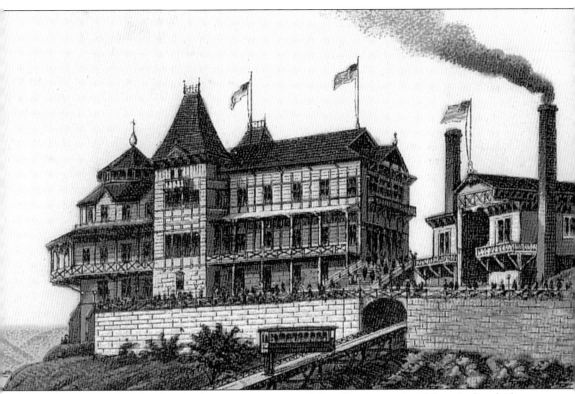

Built on a promontory beside the upper terminus of the Cincinnati & Clifton Inclined Plane Railway, the Bellevue House attracted thousands of Over-the-Rhine residents with refreshments, entertainment, and stunning views of the city below. Passage of the Owen Act in April 1888, prohibiting the sale of alcoholic beverages on Sunday, doomed this and other hilltop resorts.

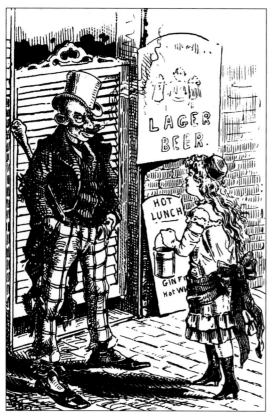

By the mid 1880s, ethnic stereotypes of German citizens were commonplace in the nation's journalism, as they were for every other ethnic group. Dialogue was conveyed in heavily accented English. Much of the disparaging attitude toward immigrants fostered the Nativist political movement that sought to deny equal rights to recent arrivals to America. In these caricatures of local Germans from an 1885 Cincinnati tabloid, a young girl is accosted outside a saloon by a lecherous German man with prominent nose and ostentatious, albeit tattered, clothes. The girl is "rushing the growler," or getting a bucket of beer for her working class father. In the other cartoon, a man in a beer garden flirts with his waitress.

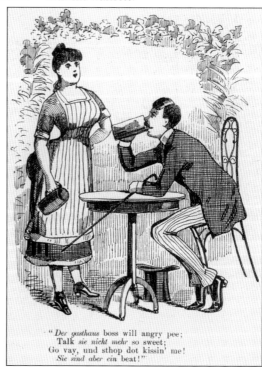

"*Der gasthaus* boss will angry pee;
Talk *sie nicht mehr* so sweet;
Go vay, und sthop dot kissin' me!
Sie sind aber ein beat!"

Charles McMicken, a prominent real estate speculator and businessman, lived at the northern edge of Over-the-Rhine on what was originally called the Hamilton Road. The house was provided to his nephew, Andrew, because McMicken was often traveling on business from Cincinnati to points along the Mississippi River down to New Orleans. A complex man who dabbled in several Christian denominations and owned slaves as well as providing money to freemen, McMicken had little education himself, but when he died in 1858, he bequeathed $1 million to the city to found a university. Eventually the university's first permanent home in 1875 would be built on this property.

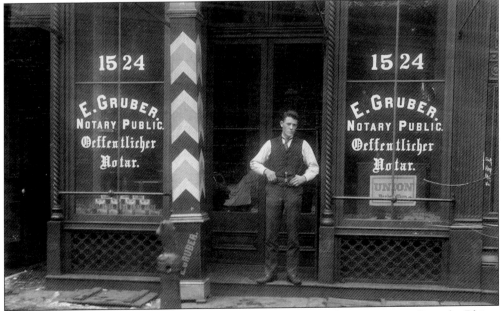

Edmund Gruber, a German businessman, operated a number of enterprises in Over-the-Rhine. In 1895, his notary business was located in this building on Vine Street. The signs in his window indicated his services to the older German residents as well as to those who spoke English.

There was a great deal of ethnic and racial tension in nineteenth century Cincinnati. Immigrants and the poor were often blamed for violence and crime in the larger context of competition for jobs and services. On the nights of March 28 and 29, 1884, the city experienced one of its most violent and bloody episodes. Two men, Joe Palmer and William Berner, were awaiting trial for the murder of Berner's employer, William Kirk. In the trial, Berner was found guilty only of manslaughter. On the night of the 28th, citizens gathered in Music Hall to discuss the corruption in the judicial system after the Berner verdict.

The meeting got out of hand and soon became a bitter shouting match. It became a mob that marched across Over-the-Rhine to the courthouse to storm the jail and lynch Berner. Unable to control the rioters, the police called out the militia to deal with them. Carried into the next night, the mob burned sections of the courthouse before order was restored with the use of the militia's Gatling gun. More than 50 people died, and another 300 were wounded. The 1884 riot has become a standard reference point in the city's history.

Occupying the buildings at 1107 and 1109 Vine Street, the Charles Doerr and Sons Company was a bakery, confectionary, and ice cream manufacturer. Walter and George Doerr took over the business after the death of their German immigrant father, Charles. These views taken at the end of the nineteenth century show the exterior of the building with the company's horse-drawn delivery wagons, and interior shows the long display cases of candy and pastries.

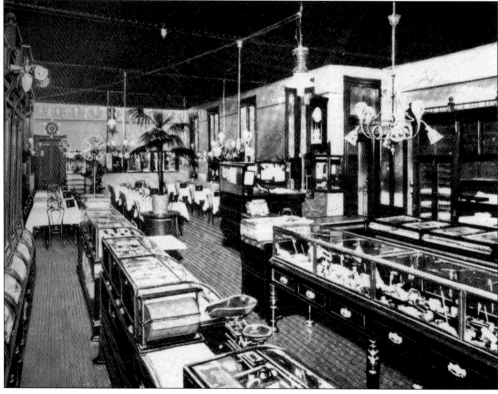

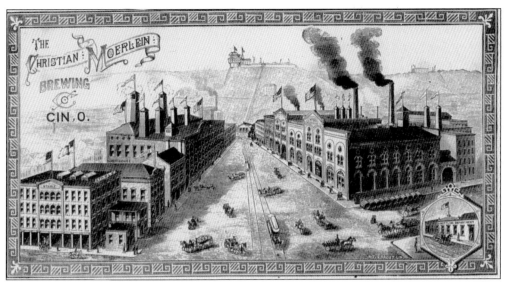

Seen here in the grandiose style of the nineteenth century lithographer is the Christian Moerlein Brewing Company, circa 1888. Moerlein was a blacksmith who began a brewery at his shop on Elm Street in 1853. By 1880, Christian Moerlein was the largest brewer in Ohio, with a production of 100,000 barrels of beer annually. By 1894, this figure jumped to half a million barrels.

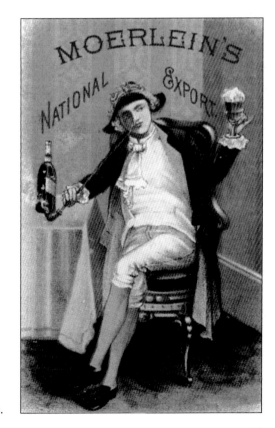

Christian's son, George Moerlein, became general manager of the brewery in 1872. He soon began expanding the company's business beyond local markets, introducing Moerlein's National Export at the 1876 United States Centennial in Philadelphia. Export sales doubled over the next two years.

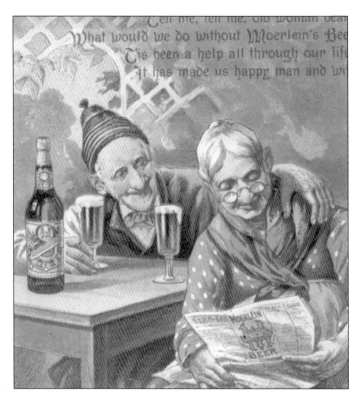

The Moerlein Brewery became a prolific advertiser, using clever and colorful images on trade cards, fans, booklets, and other items. Unfortunately, most of the company's momentum was lost when George Moerlein died in 1891 at the age of 39. Prohibition, however, struck the final blow in the demise of Cincinnati's most famous brewery. After repeal in 1933, plans to build a new brewery away from Over-the-Rhine on the suburban Paddock Road never materialized.

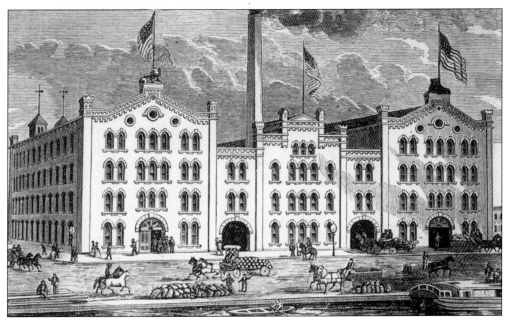

The Windisch-Muhlhauser Brewery was built in 1866 on the west side of the canal between Liberty and Wade Streets. Twenty large cellars were dug on this site before construction of the building seen here. Windisch-Muhlhauser was Cincinnati's largest brewery in the early 1870s. Although the company prospered until 1920, it too failed to survive Prohibition. The Burger Brewing Company occupied this plant from 1934 until 1973.

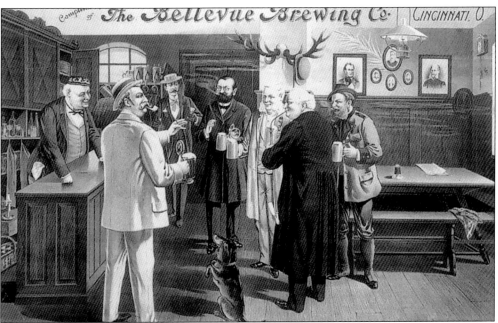

The Bellevue Brewing Company published this wonderful image of men enjoying steins of beer in a local saloon, or perhaps the brewery taproom. George Klotter founded the brewery in 1866 and his two sons joined him in the business the next year. It wasn't until 1870, however, that the name Bellevue Brewery came into use.

The Schaller-Schiff Eagle Brewery was founded in 1854, and after Schiff retired in 1866, John Gerke became a partner. He incorporated the business in 1881 as the Gerke Brewing Company, exporting half its annual production to nine neighboring states. After ceasing operations in 1913, the brewery's main building on the south side of the canal near the Plum Street bend was sold to the French-Baur Dairy.

Workers gather for a group photograph outside the Bellevue Brewery on West McMicken Street. Brewery workers were first unionized in Cincinnati, and for many years, the union's minutes and reports were written in German, reflecting the heritage of its members.

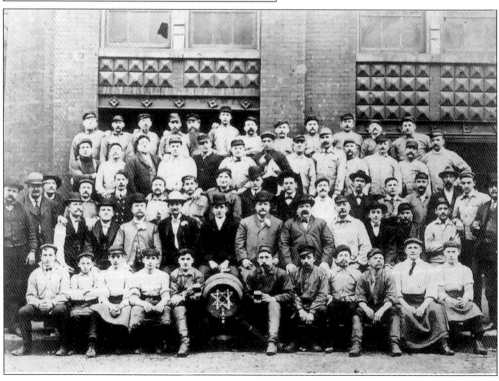

Two

THE FLOURISH AND DISPERSAL OF A GERMAN NEIGHBORHOOD: 1900–1919

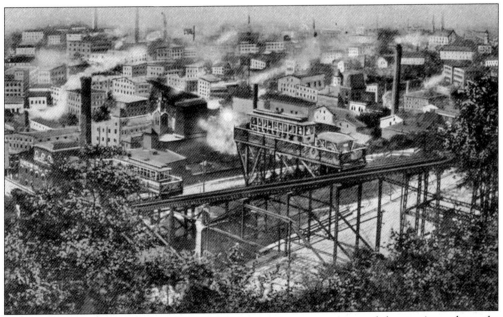

This view from the slopes of Bellevue Hill shows the sooty output of the area's smokestacks and illustrates the concentration of Over-the-Rhine buildings. Before the Bellevue and other inclines allowed people to move to the hilltop suburbs, the city's population density reached a staggering 32,000 per square mile.

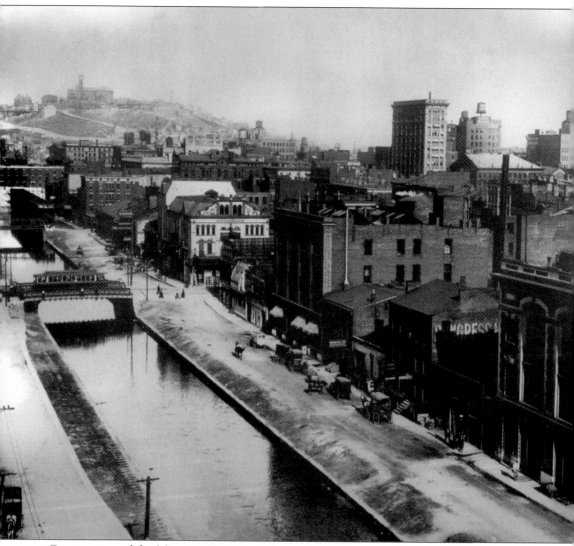

Construction of the Miami & Erie Canal began in Middletown, Ohio, in 1825. Fifteen years later it was complete, stretching 244 miles from Toledo to Cincinnati. Once bustling with canal boats hauling raw materials, farm crops, livestock, manufactured goods, and passengers, by 1907 when this photograph was taken, the canal was abandoned.

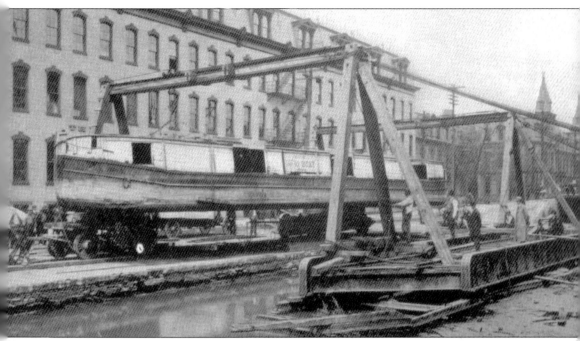

Although the canal followed what is now Eggleston Avenue to the Ohio River, the final stretch from the Sycamore Street basin onward was not navigable. When the canal was drained in October 1919, the last boat was removed by the Cincinnati Transfer Company to the Ohio River, where it was sold.

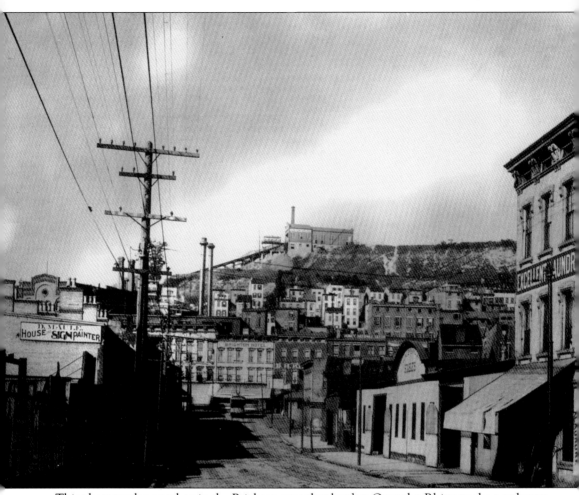

This photograph was taken in the Brighton area that borders Over-the-Rhine to the northwest. The view is north on Freeman Avenue toward its terminus at Central Avenue. Visible on the horizon is the "head house" of the Fairview Incline, built in 1892 to carry the electric cars of the Cincinnati Street Railway up to Clifton Heights.

One of the most popular venues for theater in Over-the-Rhine was Hubert Heuck's Opera House. The neighborhood had a number of theaters that brought a large measure of vivacity to everyday life there. Heuck's theater was also known as the "People's Theater," and his considerable impresario skills brought a lively mixture of light opera, German plays, and vaudeville to the stage.

"THE PLAY IS THE THING"
— SHAKESPEARE.

"AND HEUCKS IS THE PLACE"
— THE PUBLIC.

PROGRAM
HEUCKS

McNEILL

HUBERT HEUCK
The Heuck Opera House

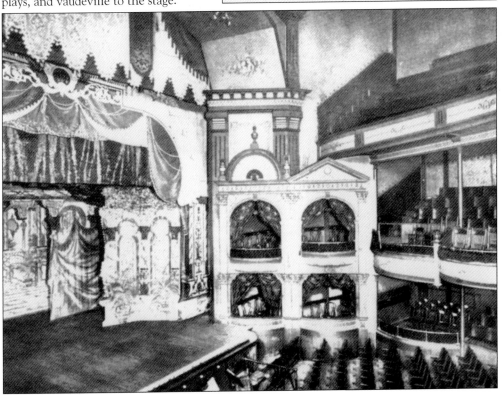

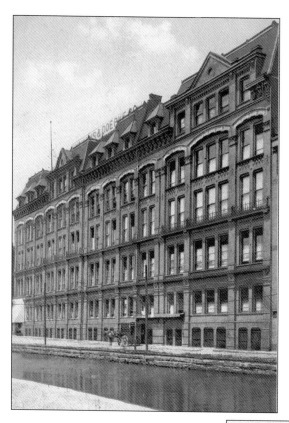

Occupying an entire city block along the canal from Main to Hunt Street, the Alms & Doepke Company was by 1900 the second largest mercantile store west of New York City. Robert Doepke, a descendant of the founders, reported that once, a company wagon loaded with Easter bonnets was accidentally backed into the canal, spilling its cargo. The ruined hats floated down the canal, creating a colorful spectacle.

Returning to Cincinnati following the Civil War, Frederick Alms founded the Alms & Doepke Company with his brother William and with William Doepke. This huge department store served area residents for decades, but as Over-the-Rhine declined, so did business. The store closed its doors in 1954, and today the building serves as offices for Hamilton County government.

The tobacco trade was a major industry in Cincinnati during the nineteenth and early twentieth centuries. The proximity to the tobacco fields of Kentucky and east of the city in Brown County made the Queen City a big producer of cigars, pipe tobacco, and chewing tobacco. Improved rail transport and shipping after the Civil War also allowed Cincinnati factories to bring in the finest tobaccos from Cuba. While most of the trade was centered in the streets closest to the riverfront, one of the largest cigar factories was that of the Fritz Brothers, just beyond the canal in Over-the-Rhine. Richard Fritz is seen here in a 1905 caricature as part of a series on local businessman, and in the promotional postcard, the company promotes their Marguerite Havana Cigars, using a romantic painting to attract the smoker.

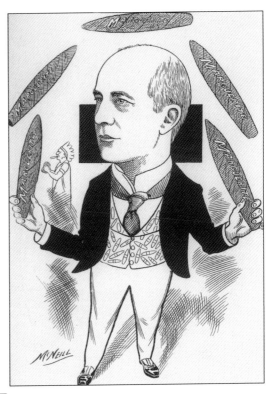

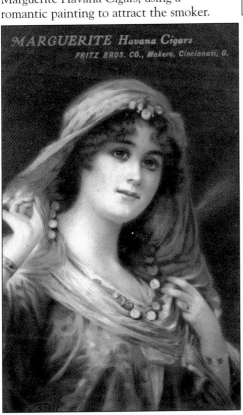

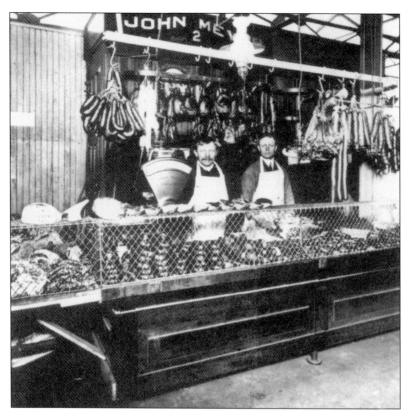

The manufacture of sausage became a major offshoot of Cincinnati's prosperous meat packing industry. The local demand originated in the 1840s as the large numbers of German immigrants arrived. The John Meyer sausage stand in Findlay Market was typical of those serving Over-the-Rhine in the late nineteenth and early twentieth centuries.

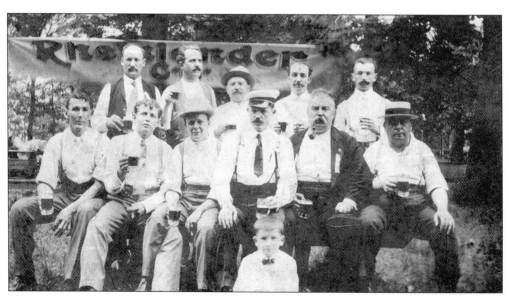

There were dozens of German clubs and organizations in Cincinnati, from bowling, fishing, and dance clubs to fraternal organizations and savings and loans. In this photograph, a group of German barbers in the Rhinelander Club enjoy their steins of beer in Washington Park.

The Frederick Biemer Distillery Company printed sets of promotional postcards in 1908 that emphasized the German nature of Over-the-Rhine. The cards played upon the popular stereotypes of German dress and habit.

MA IS GERMAN, PA IS GERMAN
AND I AM GERMAN TO.

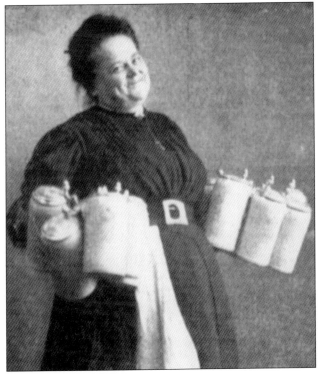

In this photograph, the server in a neighborhood beer garden pauses for a moment to have her picture taken, each hand holding five large beer steins. The feat is repeated even in the twenty-first century every fall at an Oktoberfest contest as Cincinnati barmaids vie with each other to carry the most foaming steins at once.

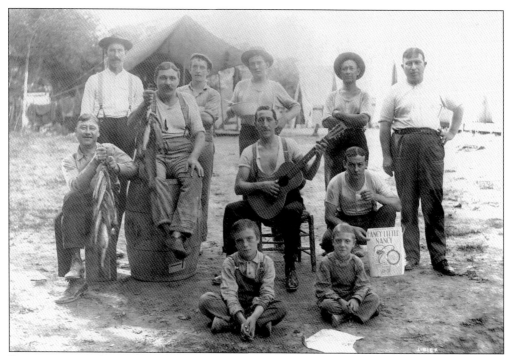

Brewer Louis Hudepohl believed that beer, music, and good times were all part of a happy life, and he often took his employees on picnics and fishing trips. Of course, his own Hudepohl beer was the refreshment of choice. In this photograph, brewery employees pose in 1907 at Friendship Camp with guitar, beer barrel, and their strings of fish.

Were you ever in Cincinnati, Ohio?
Where they brew good beer and are never slow,
Where the drinking bars are certainly stars
And are known the world over—even in Mars,
But space don't permit of telling half
Just come over soon and—it is to laugh,
And when you reach here we'll kill the fatted calf.

This postcard touts the pleasures of life in the Over-the-Rhine saloons.

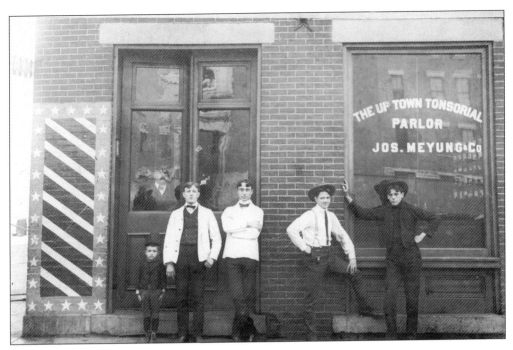

The German-born barbers in Over-the-Rhine were quick to unionize their profession, beginning Barbers' Union Local #49 in the neighborhood. Joseph Meyung was their leader, operating the union out of his shop, the Up Town Tonsorial Parlor. In the top picture, taken in 1904, Meyung's employees and a couple of customers pose outside the parlor as he looks on from behind the window. To the left of the little boy in the picture, the stars and stripes decorate the edge of the building. In the 1912 photograph below, Meyung mustered his family into his carriage, took the reins, and led the way in a Labor Day parade.

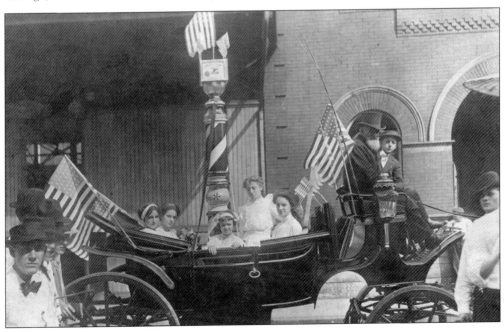

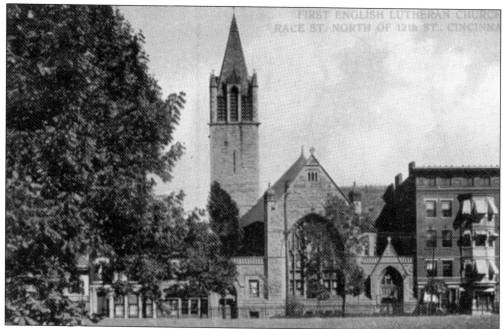

FIRST ENGLISH LUTHERAN CHURCH
RACE ST. NORTH OF 12th ST., CINCINNA

Choosing to conduct its services in English, not German, the First English Lutheran congregation dates to 1841. The building, an eclectic architectural composition, featured a magnificent Gothic Window and a Romanesque tower stretching 130 feet into the air. The church, located at 1208 Race Street facing Washington Park, still serves a Lutheran congregation.

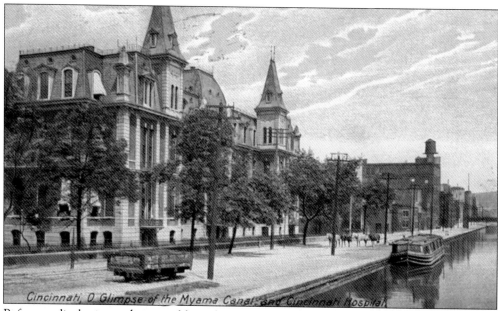

Cincinnati, O. Glimpse of the Myama Canal and Cincinnati Hospital

Before medical science discovered how diseases are transmitted, many believed that vaporous emanations from the canal waters caused malaria. Proximity to the canal and deplorable conditions within the complex prompted Dr. Christian Holmes to spearhead the building of a new city hospital up the hills on Burnet Avenue. In 1915, the new General Hospital opened, and this building was demolished.

The German-American Turners organization was formed in 1848, based upon an organization in Germany that promoted physical health, mental health, and citizenship as parts of a whole. In Cincinnati, a Turners club began in 1848 in a small building at the corner of Canal and Plum streets. By 1850, the Turners had a gymnasium, and by 1860, their influence was such that a physical education program became part of the Cincinnati Public Schools curriculum. Turner festivals began around the country in the nineteenth century, and in 1909, a quadrennial *turnfeste* came to Cincinnati. The Turners often gave exhibitions of their gymnastic skills for the public. In the photographs here, a Turner father and his children display their prowess during an Ohio Knights Templar conclave at Music Hall in 1908. The other photograph shows a Turner gymnastic group holding the American flag aloft during the 1909 festival, to which more than 50,000 people journeyed to Cincinnati.

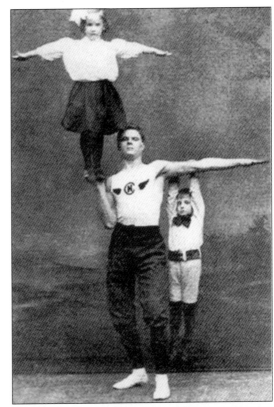

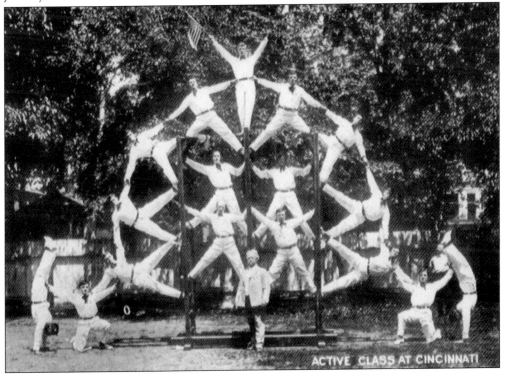

ACTIVE CLASS AT CINCINNATI

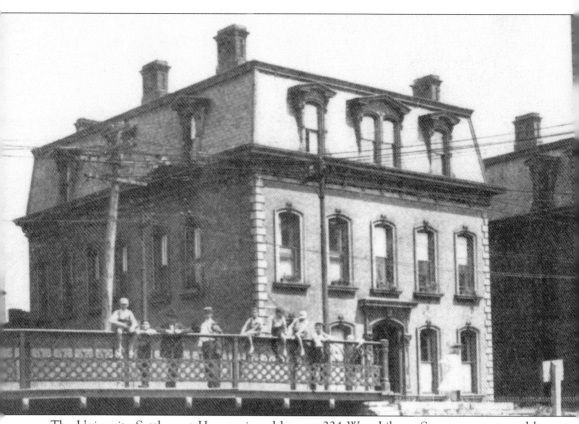

The University Settlement House, viewed here at 224 West Liberty Street, was operated by faculty and staff at the University of Cincinnati for inner city children. The settlement houses in America and England followed the philosophy that a wholesome atmosphere of learning and activities could rescue children from the negative influences of city streets. The University Settlement was founded in 1899, always having two to eight resident workers and up to a hundred volunteer workers. The social clubs at the house had a membership of more than 250 children. In addition there was a kindergarten, a mothers' club, and industrial classes for job training. Recent immigrant children were taught English and lessons in civics. Drama clubs, gymnastics teams, and basketball squads all worked to provide a healthy life in what was a Progressive Era movement to improve life for the poor and disadvantaged.

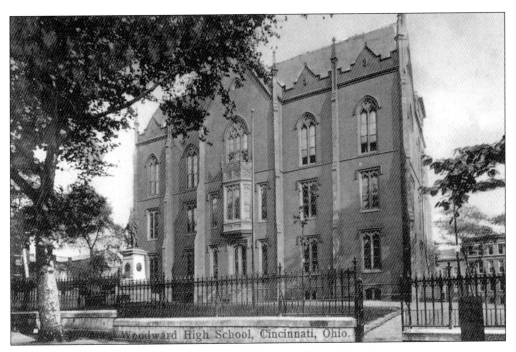

Opened in 1831, Woodward was the first high school west of the Alleghenies. The building illustrated in these postcard images was completed in 1855. President and Chief Justice William Howard Taft graduated from Woodward in 1874, and William Holmes McGuffey, famous for his Eclectic Readers, taught at the school for two years. His brother, Alexander, was on the faculty for thirty. This building, located between Sycamore and Broadway above Thirteenth Street, was razed in 1907.

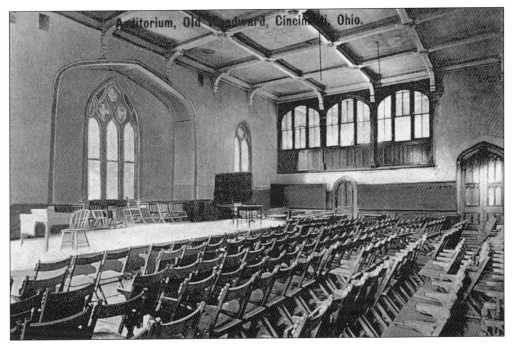

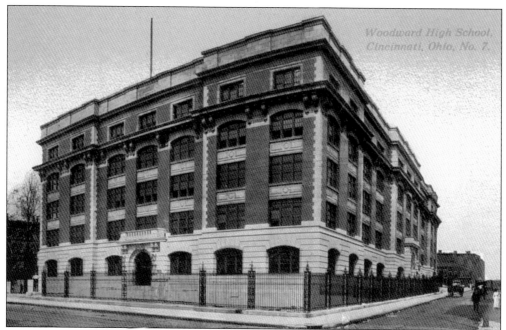

Built on the site of the former school, this handsome Renaissance Revival structure was completed in 1910. It served Over-the-Rhine residents for more than forty years until population decline finally forced Woodward to relocate north of the city at Reading Road and Seymour Avenue in 1953. Today, this building is home to the Cincinnati's School for the Creative and Performing Arts.

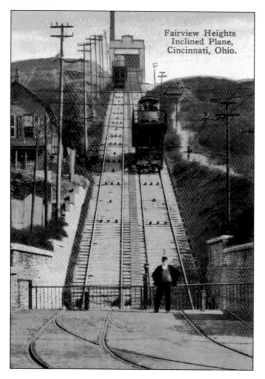

The Fairview Incline ran from McMicken Avenue up to Fairview Avenue in Clifton Heights. Also known as the Cross-Town Incline, it distinguished itself by being the last incline built (1892) and the shortest (700 feet). The incline was closed in 1923, replaced by a road that wrapped around Fairview Hill to the summit.

Constructed in 1876, the Bellevue Incline ran from McMicken Avenue at the head of Elm Street up to Ohio Avenue. At the top was the Bellevue House, a favorite summertime destination for Over-the-Rhine residents seeking to escape the sweltering heat and humidity of the basin. After 1890, residents could take a streetcar up the incline and on to Burnet Woods or the Cincinnati Zoo. The Bellevue Incline was closed and dismantled in 1926.

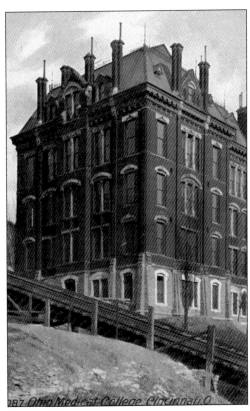

Situated beside the Bellevue Incline and visible from most of Over-the-Rhine, this imposing structure was the first permanent home of the University of Cincinnati. Built on property willed to the city for this purpose by businessman Charles McMicken, classes were held here from 1875 until 1895 when UC moved up the hill to Burnet Woods. The university's medical school held classes here until 1916, the students sometimes horrifying incline passengers with anatomy class arms and legs waved out the windows at them. The building was demolished in 1935, and UC graduate Joseph Strauss obtained some alma mater bricks to place in his newly designed Golden Gate Bridge in San Francisco.

1887 Ohio Medical College Cincinnati O.

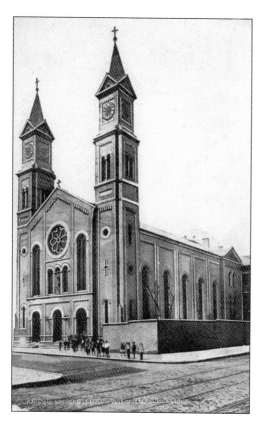

St. Francis Seraph Church carried on the tradition of that first small wooden church erected at Liberty and Vine in 1819. In 1844, Franciscan friars from the province of St. Leopold in Austria traveled to Cincinnati at the request of Archbishop John Purcell. German Catholics were arriving in Over-the-Rhine in great numbers, and there was a need to minister to them in their own language. The church was consecrated in late December 1859 on a cold, rainy day. Despite the muck and mire of the roads and surrounding the church, Cincinnati Catholics arrived in throngs to the ceremony. Today, the church is a community fixture at 1615 Vine, ministering to area residents in the tradition of Franciscan social justice and education. St. Francis Seraph, which has operated a soup kitchen since 1980, provides an outreach center for job training and a parish nurse for holistic education and counseling, and runs the parish school.

The 1910 Ohio Valley Exposition was held at Music Hall to mark the recent completion of Fernbank, then the nation's largest moveable dam, which spanned the Ohio five miles downstream from Cincinnati. On opening day, President William Howard Taft pressed a telegraph key in Washington D.C. to signal every factory and steamboat in Cincinnati to sound its whistle. The resulting din proclaimed the exposition officially underway.

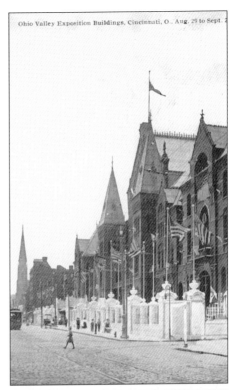

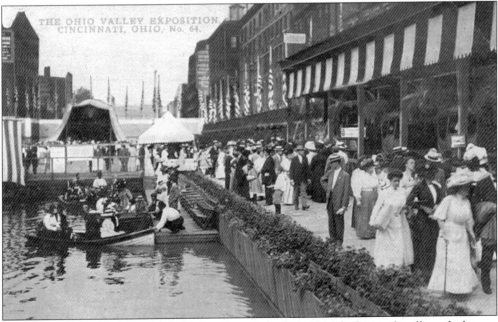

This postcard image shows how the canal was transformed with flowered walls and pleasure boaters for the exposition. Exhibit buildings were constructed along the canal, and sometimes over it. Here is where the Transportation Building and the popular Swiss Over-the-Rhine Restaurant were located. In Washington Park, the Aerodome provided many visitors with their first glimpse of a real airplane.

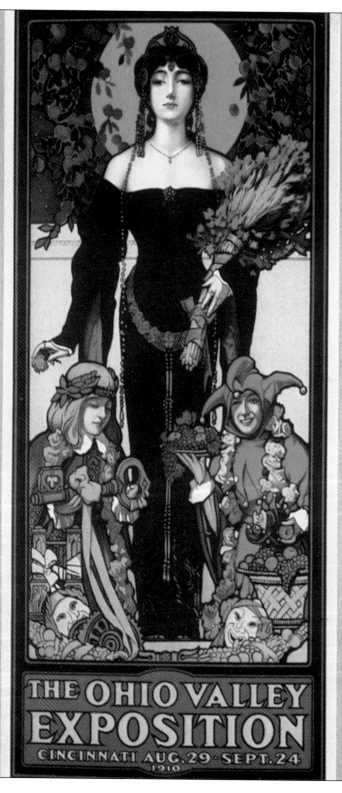

This alluring poster, advertising the Ohio Valley Exposition, was designed and printed by the Strobridge Lithography Company at their plant on North Canal Street.

48

A native of New York, Mary Emery moved to Cincinnati after marrying Thomas Emery in 1866. After both of her children died when they were very young, she channeled her energies into a variety of social causes. However, it was after her husband's death in 1906 that she became most active as a philanthropist. Soon after, she financed the construction of the Ohio Mechanics Institute and Emery Auditorium, which she dedicated to her husband's memory.

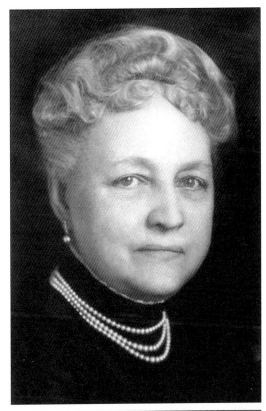

Construction on Emery Auditorium began in September 1909. Originally designed for OMI programs and lectures, the plans were redrawn to allow sufficient seating for symphonic orchestra concerts. As anticipated, the Cincinnati Symphony Orchestra moved from Music Hall and performed here from 1912 to 1936. Emery was the first concert hall in the country to have unobstructed seats, a feat accomplished by supporting each balcony on a 33 ton steel beam.

Born in Berlin in 1836, Ernst Lietze was one of thousands of German craftsmen who came to Over-the-Rhine in the nineteenth century to apply their talents. Upon arriving in Cincinnati in 1859, he immediately began work in a West End machine shop. By 1861 he was designing naval gun boats, and after the Civil War he switched to the publishing trade, designing a typecasting machine and a multiple color press. A man of considerable accomplishment, Lietze felt his greatest achievement was as a teacher. For thirty years, he taught in the night school of the Ohio Mechanics Institute. Even after his retirement, he invited students into his home on Liberty Street to help them with their designs for the trade expositions. One student said of him that he personified the motto of OMI: "We live for those who need us, for the good that we can do."

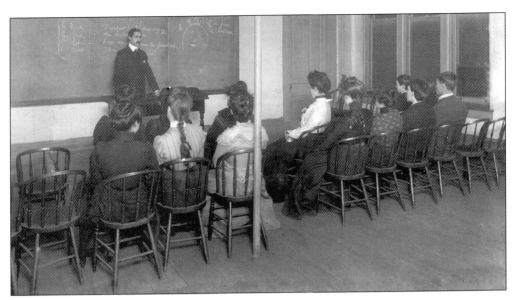

The Ohio Mechanics Institute was founded in 1828 and at first offered only evening classes so that workers and apprentices in the city could take advantage of the courses of study. The intent was to train the students to provide a technically competent workforce for the city's industries. Trade courses included drafting, mechanical engineering, lithography, mechanical design, and many others. In addition, OMI offered other courses that would produce a well-rounded citizen. Both men and women attended the school early on in its history and in these views, two of the classrooms are shown. The top one is a French class, and the one below shows an electrical engineering classroom. Day classes began being offered in 1901, and in 1919, they were instituted under the name of the Ohio College of Applied Science. By 1934, cooperative education was brought into the curriculum, and in 1969, the two joint schools, OMI and OCAS, merged with the University of Cincinnati and today is the university's OMI College of Applied Science.

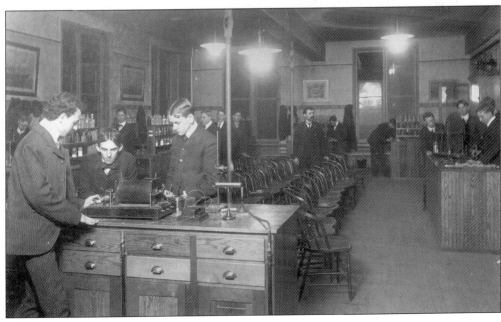

The OMI building provided through the philanthropy of Mary Emery was located on the busy corner of Walnut and the canal. Because of the density of downtown and Over-the-Rhine structures, there was little available space for recreation. Typical of the situation in other American cities, the inner urban areas made do with what one sports historian has termed "confined urban space." Boxing and basketball became the favored school sports in a crowded city; football and baseball teams usually had to venture afield from the school grounds to find a place to play. OMI provided a rooftop recreational area where calisthenics could be done, as well as basketball practice. A twelve-foot fence surrounded the court to keep the ball in play and to keep it from dropping to the street below.

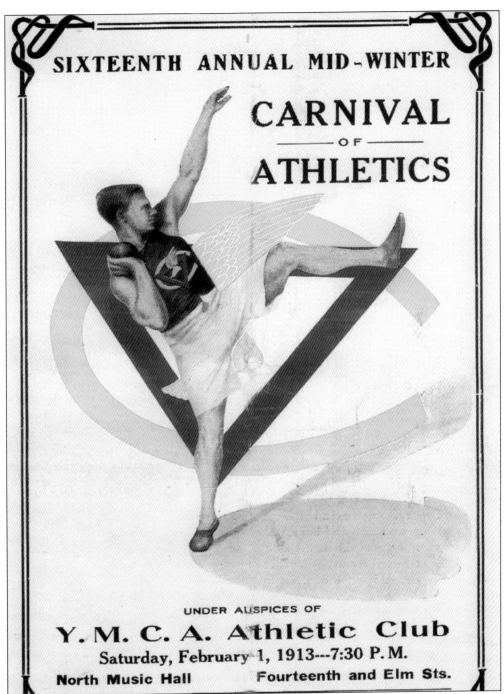

SIXTEENTH ANNUAL MID-WINTER

CARNIVAL
— OF —
ATHLETICS

UNDER AUSPICES OF
Y. M. C. A. Athletic Club
Saturday, February 1, 1913---7:30 P. M.
North Music Hall Fourteenth and Elm Sts.

The main venues for indoor sports in Cincinnati in the years before World War II were the Ohio National Guard Armory in the West End and Music Hall in Over-the-Rhine. There were dozens of amateur sports clubs in the city, and each winter one or another of them would sponsor a competition in track and field. One of the strongest organizations was the YMCA, which fielded teams in a number of sports, including swimming, basketball, and football. This poster is for the 1913 Carnival of Athletics, which the Y sponsored for the sixteenth time.

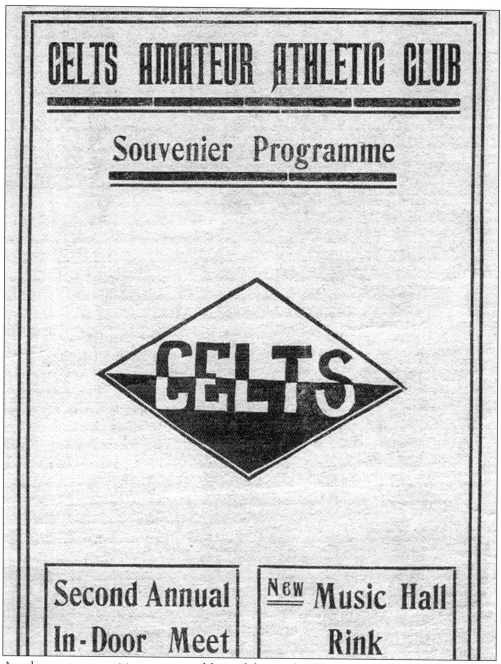

CELTS AMATEUR ATHLETIC CLUB

Souvenier Programme

CELTS

| Second Annual In-Door Meet | New Music Hall Rink |

Another very competitive amateur athletic club was the Cincinnati Celts. The Celts often vied with the YMCA and the various National Guard companies for supremacy in indoor track and field. For their competitions, they did as the Y did: outstanding high school teams, the University of Cincinnati, military teams, the Cincinnati Athletic Club, the Avondale Athletic Club, and the Christ Church team were all invited to compete in sprints, short relays, the discus, and the hurdles. The Celts also had a football team in the fall and, in fact, were one of the earliest professional squads when they played in the American Professional Football Association following World War I.

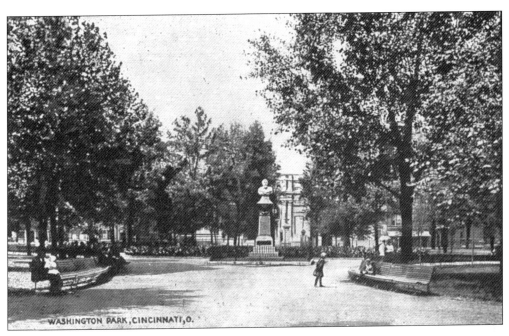

WASHINGTON PARK, CINCINNATI, O.

We have the dead to thank for Washington Park. During the first half of the nineteenth century, four different religious denominations had cemeteries here, forcing the expanding city to develop around it. By mid-century, speculation that corpses emitted unhealthful vapors prompted the city to act. The land was purchased and the bodies re-interred elsewhere. The park was dedicated in 1861. Washington Park occupies almost six acres of land between Race and Elm Streets and is the largest green space in Over-The-Rhine. The octagonal bandstand seen in the postcard dates from 1912, and concert and recreational activities are still held here.

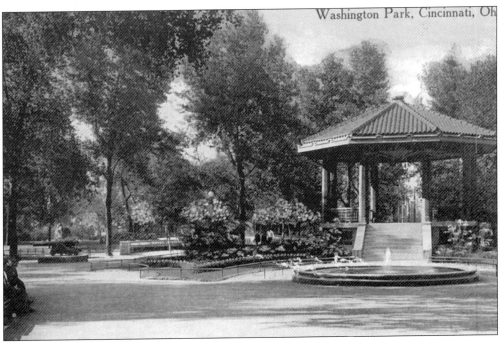

Washington Park, Cincinnati, Oh

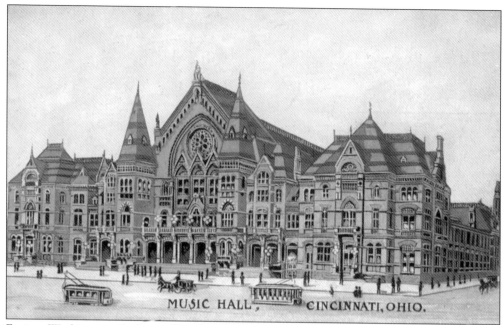

MUSIC HALL, CINCINNATI, OHIO.

Facing Washington Park on Elm Street is magnificent Music Hall. This building has been home to the Cincinnati May Music Festival since 1878, and hosted every industrial exposition since 1879. The Cincinnati Symphony Orchestra has performed here since 1896, with the exception of residence in the Ohio Mechanics Institute's Emery Auditorium from 1912 to 1936. Designed by Samuel Hannaford, difficulty in classifying its architectural style has led to its being dubbed "Sauerbraten Byzantine."

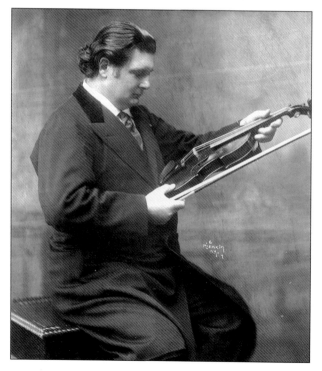

Belgian violinist Eugene Ysaye had an international reputation in the 1880s with his string quartet, receiving great acclaim in France, Norway, England, Russia, and Germany. In 1894 he began an American tour, and his success led him to expand his talents into conducting. From 1918 to 1922, Ysaye served as the conductor of the Cincinnati Symphony Orchestra, before returning home to his native Belgium where he died in 1931.

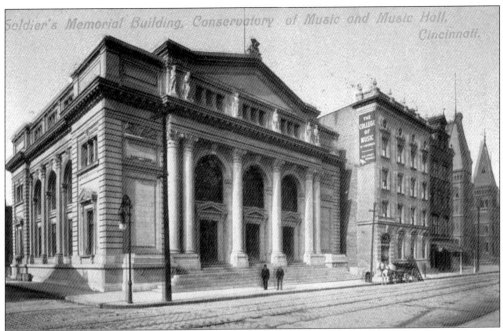

Soldier's Memorial Building, Conservatory of Music and Music Hall, Cincinnati.

In the same block of Elm Street is the Hamilton County Memorial Building, now known simply as Memorial Hall. Dedicated in 1908, it was built as a tribute to the county's soldiers, sailors, marines, and pioneers. Designed by Hannaford & Sons, it is the finest Beaux Arts building in Cincinnati. Inside, dual marble stairs lead to a beautiful 600-seat auditorium.

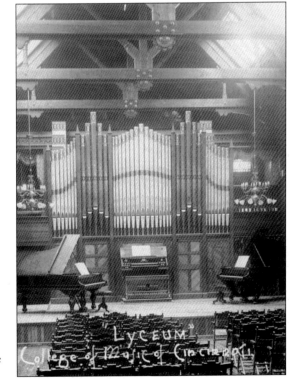

When the Odeon was completed in 1884, the College of Music of Cincinnati became one of the first music schools in the nation to have its own concert hall. In 1889, it added a second hall called the Lyceum. Located on property adjoining the Odeon, the Lyceum seated 400 people and had a $15,000 Roosevelt organ. Tragically, fire destroyed both facilities in 1902.

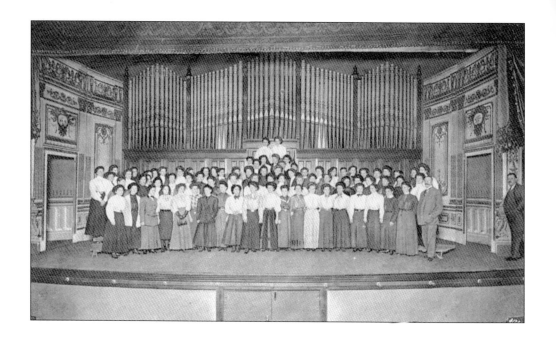

In 1911, the College of Music replaced the Odeon and the Lyceum with a single concert facility. The new hall had a seating capacity of 700 and utilized fireproof construction materials. These photographs of the college orchestra and the college chorus were both taken in the new facility.

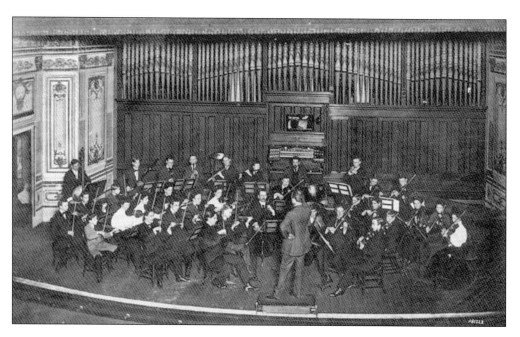

Giacinto Gorno was one of three brothers educated at the Milan Conservatory of Music. In Italy, the brothers were known for their amateur weightlifting skills and for their sense that music was one of the great joys of life; it must be played and sung with élan and fun. When the Gorno trio came to Cincinnati, Giacinto, the only married brother, brought his wife Emilia to teach Italian to opera students at the College of Music. Giacinto also sang in the first live music broadcast of radio station WLW in 1922.

Romeo Gorno emigrated to America in the 1880s with Giacinto after their brother Albino became an accompanist for opera diva Adelina Patti on an American tour. He was a favorite not only with the College of Music students, but with his private students as well, delighting them with his jokes and carefree personality.

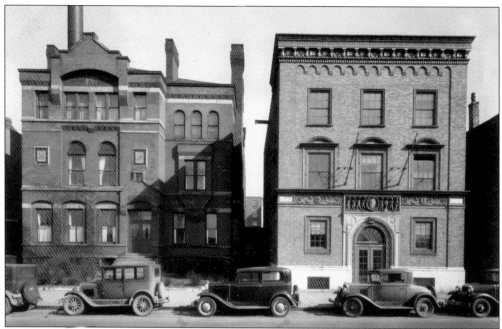

In 1902, and again in 1918, properties along Elm Street were purchased to build a dormitory and studios for the students. The last building added to the College of Music complex is the only one remaining today. Built in 1927, the Administration Building contained offices, studios, the library, and an assembly hall. This photograph taken from the Central Parkway median strip shows the newest college building standing beside the oldest. Today it serves as a union hall.

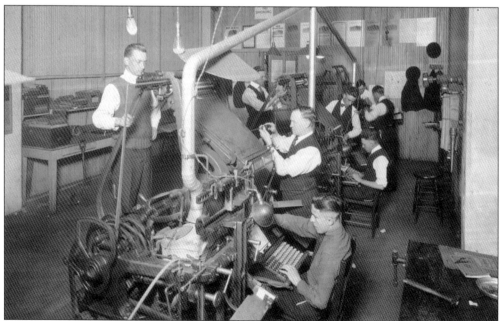

With the creation of the Federal Board for Vocational Education, schools like the Ohio Mechanics Institute could improve their program offerings. This 1919 image shows Federal Board students at OMI learning the printing trade through linotype operation and mechanics.

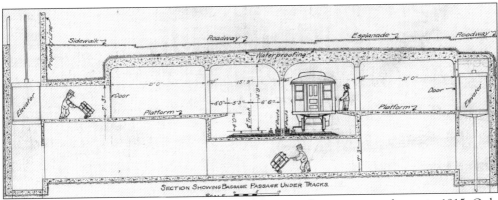

Plans to use the bed of the Miami & Erie Canal for a rapid transit system began in 1915. Only scattered pools of water and mucky weed-choked, trash-filled stretches of the canal remained. It was an eyesore and a health hazard. The rapid transit would use the canal bed to move people from the suburbs and outlying neighborhoods to downtown. This plan, sketched shortly after the United States entered World War I, shows how baggage would be moved under the subway platforms.

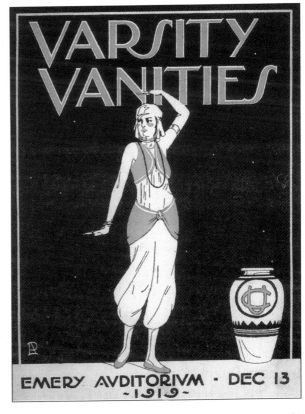

With the coming of Prohibition, the mood of America's reaction to it was fostered by the lampoons of music and theater. In this production by a University of Cincinnati student group, the Varsity Vanities held at the Emery featured songs about "Gus the Sudspiller" and "Mr. Stillsoused."

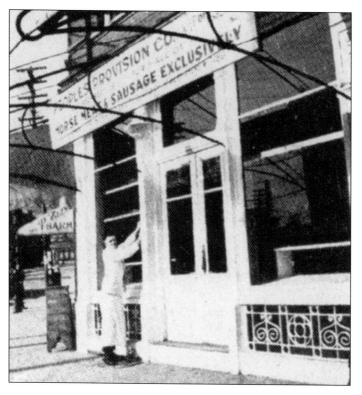

As America's participation in World War I increased, the anti-German sentiment in Cincinnati grew as well. Hysteria mounted as traditional German street names such as Bremen were changed to "American" names like Republic Street, and the teaching of German was discontinued in the schools. In effect, the city disavowed the contributions made to Cincinnati heritage by its ethnic German citizens. Other war-related activities were part of the local climate as well. Victory gardens were planted in Burnet Woods, but as these photographs illustrate, beef was scarce.

This butcher shop at the corner of McMicken and Vine Streets was called the People's Provision Company, advertising "horse meat and sausage exclusively" while inside, the old gray mare was displayed in the meat cases.

Three

FROM A PHANTOM SUBWAY TO A NEW APPALACHIAN ENCLAVE: 1920–1945

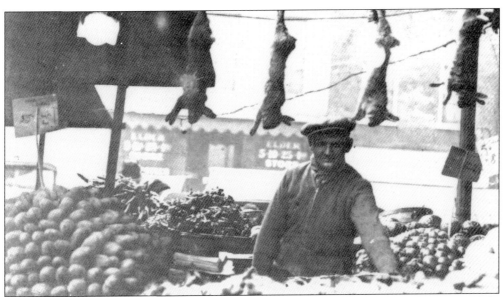

Have a craving for hasenpfeffer? A Findlay Market vendor displays his rabbits for the German dish.

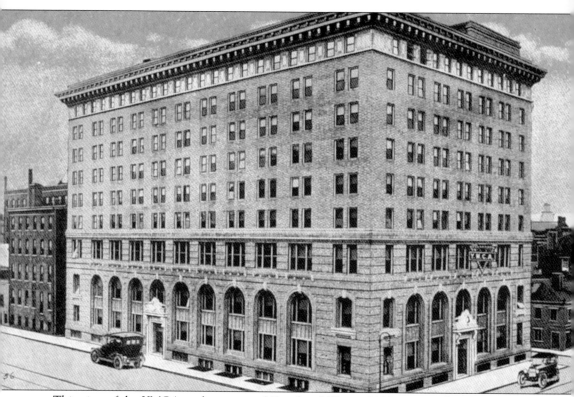

This view of the YMCA at the corner of Canal and Elm in 1920 suggests that the subway was completed and covered by a road. In truth, when the YMCA was opened in 1918 at the end of World War I, it was built next to the canal that had yet to be replaced with subway tunnels. On March 31, 1917, Cincinnati native and former president William Howard Taft was present for the laying of the corner stone. Seepage from the water left in the canal caused problems in pouring the concrete for a swimming pool in the Y.

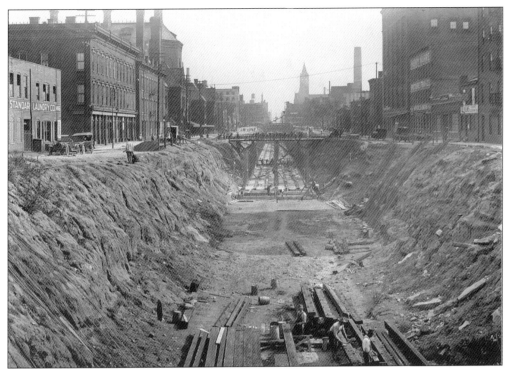

After the end of the war, planning for the subway project could be renewed in earnest. By 1920 the canal was drained, deepened, and widened to accommodate the subway bed. A photographer was retained by the Rapid Transit Commission to document every step of the construction. His notes were detailed down to the date and time of day for each photograph. This image facing south was taken from the Fifteenth Street temporary bridge on September 10, 1920, at 3:25 p.m.

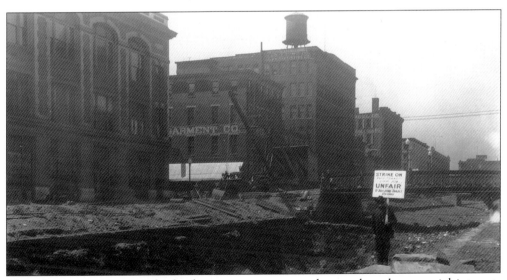

The subway project created jobs, but not everyone was happy about how special interests in city government determined who would be awarded the contracts. This lone striker is standing in the canal bed with a sign that reads "Strike On. Rapid Transit Loop Job Unfair to Building Trades Unions."

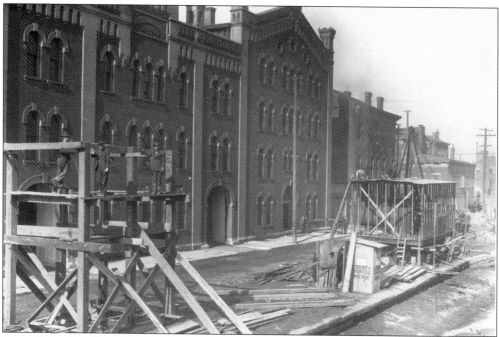

As work on the subway began in 1920, Prohibition ended work at Windisch-Muhlhauser's Lion Brewery on Canal near Liberty Street.

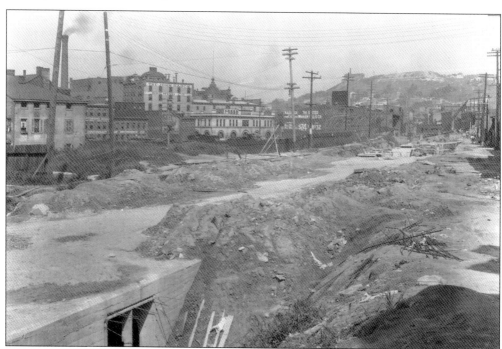

This picture was taken by the subway photographer on August 19, 1921, at 10:22 a.m. The view is north from Findlay Street and shows the subway tubes completed and awaiting grading for the median and roadbeds. The back of the John Hauck Brewing Company on Dayton Street can be seen at the top center of the photograph.

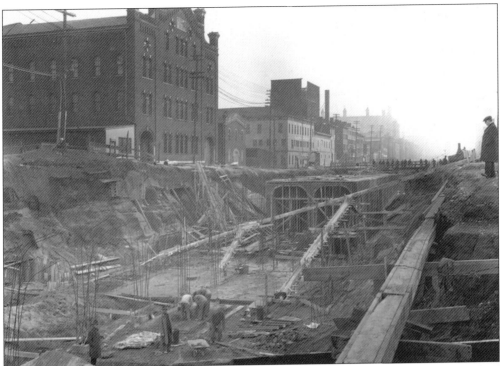

Looking east along what would eventually become Central Parkway, the silhouette of Music Hall is clearly visible at the upper right. The College of Music's original building can be seen next to it. Also of interest is the detail that can seen in the forms used to shape the concrete into tubes.

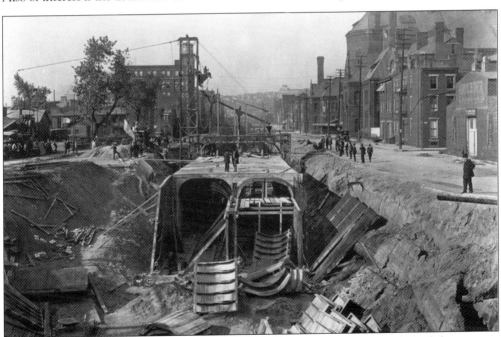

Facing north from the Twelfth Street temporary bridge, the photographer showed the erection of wood forms for a section with a ventilator opening.

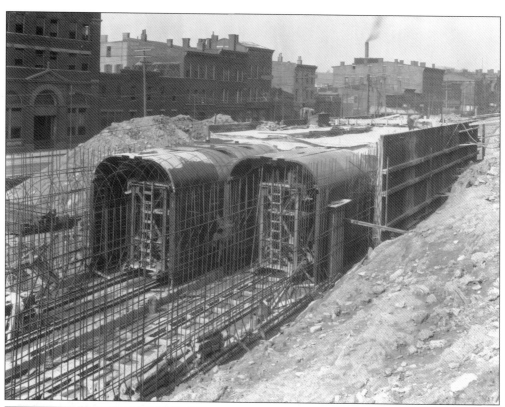

In this early August morning photograph in 1921, the steel reinforcing material used inside the concrete is in place for a subway section beside the Wetterer Brewery.

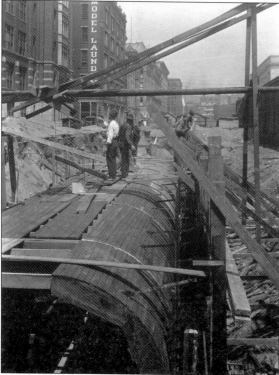

Workmen stand atop the wooden forms before concrete is poured. The Model Laundry Company stands on the left.

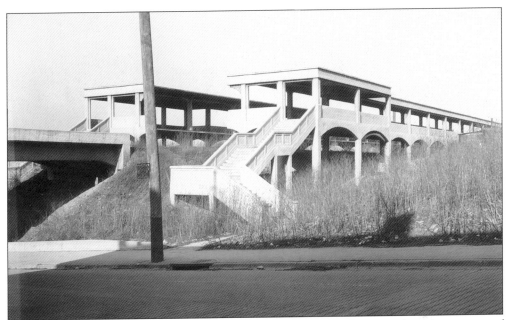

Some passenger platforms were completed for the subway at sections where it rose out of the ground, but of course they were never used, and after the abandonment of the project they became weedy monuments to a failed urban plan. This photograph is of the Marshall Avenue station in 1926.

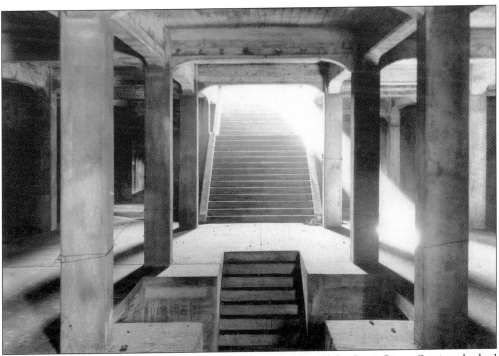

This image is what one of the entry stations, the west steps of the Race Street Station, looked like. Passengers would have descended the steps to enter the subway cars at their right and left. It became part of Cincinnati's underground ghost town.

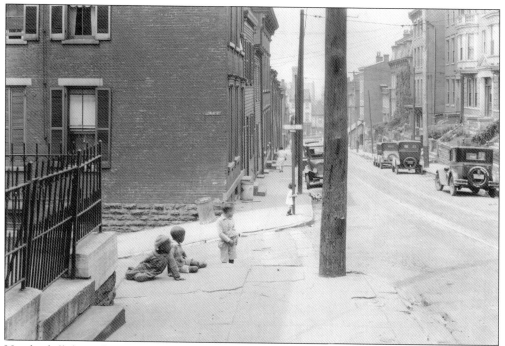

Up the hill from the construction in lower Over-the-Rhine, daily life quietly continued. In this view of the southeast corner of Milton and Broadway Streets, neighborhood children are focused on something happening across the street.

The working class character of the neighborhood remained in the 1920s and '30s, with Over-the-Rhine's steep ascent to the hillsides and sidewalk gardens. In this beautiful 1929 photograph of the corner of Milton and Broadway, a little girl cradles her doll as she steps up to the street.

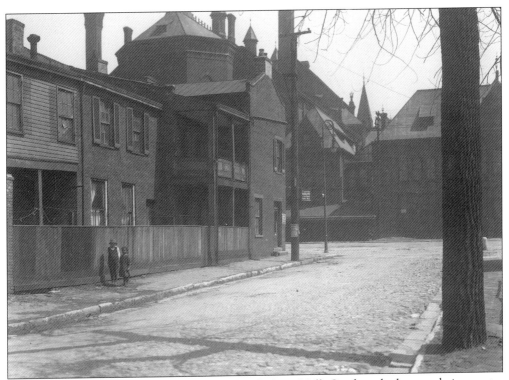

Two children face the camera on a street behind Music Hall. On the telephone pole is a poster advertising a penny circus, and the business sign on the corner reads: "E. Van Pelt. Bricklayer, Plasterer, Cement Work."

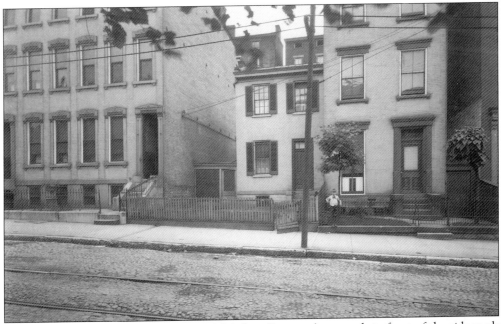

In this view of a row of residences on McMicken Street, a boy stands in front of the tidy yards and flowering plants.

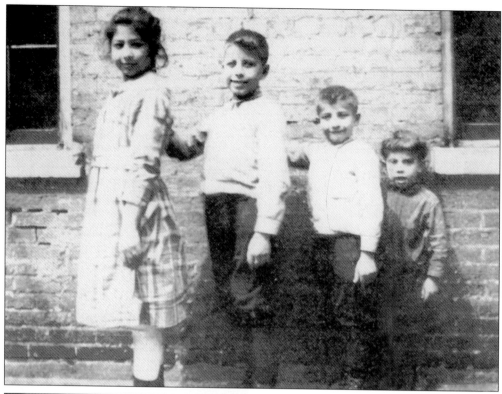

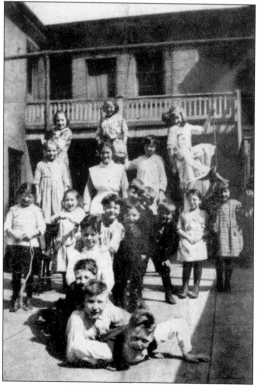

The Emanuel Community House, with facilities on Race and on Republic Streets, was a settlement house along the same philosophy of the University Settlement House. Using the slogan, "The Use of a Nation's Leisure is the Test of Its Civilization," Emanuel embraced the idea that wholesome recreation helped eliminate the moral and physical dangers of the inner city, like pool rooms and dance halls. Welcoming the small children of immigrants, Emanuel "Americanized" them with language lessons, physical fitness, and hygiene instruction. Italian siblings Eugenia, Mikie, Joe, and Charlie Curro pose outside the center, while the other children gather round in the interior courtyard. Though removed from the core of Over-the-Rhine today, the Emanuel Center still exerts a strong community presence, teaching childcare and job skills. (Photos courtesy of Maria Kreppel.)

These Woodward High School seniors in 1924 were participants in their school's "Oratorical Contest." Pictured from left to right are Ashton Welsh, Charlotte Lightfield, Nelson Murphy, and Theodore Berry. Berry was the winner, with "Chaos Beyond," and spoke at Music Hall on commencement night. Berry went on to a distinguished career as an attorney, Cincinnati's first African-American mayor, and a national civil rights leader under President Lyndon Johnson.

Though it was an inner city training college with only a rooftop recreation space, the Ohio Mechanics Institute still fielded a football team from 1912 to World War II. Pictured here on the rooftop basketball court, the 1924 squad took on Cincinnati-area clubs and schools wherever they could find a flat field and erect goalposts.

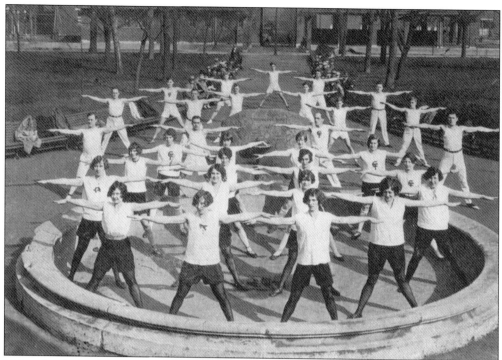

Using the drained fountain in Washington Park, a group of Central Turners Society women and men demonstrate synchronized calisthenics on October 13, 1929. Their activities were to promote a gymnastics exhibition and a health pageant being held in Music Hall later that day.

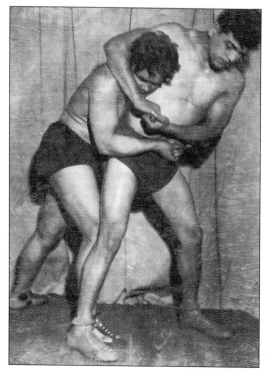

Variously called "The German Oak," "The Flying Dutchman," or "Dynamite Joe," Joseph Weggesser was one of the great wrestlers to come out of Over-the-Rhine when the neighborhood had considerable boxing and wrestling talent. During the Depression, Weggesser wrestled in Music Hall and in Rappold's, an indoor arena on Vine Street, often taking on his local rivals, Frenchie LaRance and Sailor Parker. As part of his wrestling routine, a bevy of ladies would surround Weggesser as he climbed out of the ring, covering his thighs in kiss marks. After his career, "The German Oak" refereed and coached wrestling at the YMCA. (Photograph courtesy of Joan Meister.)

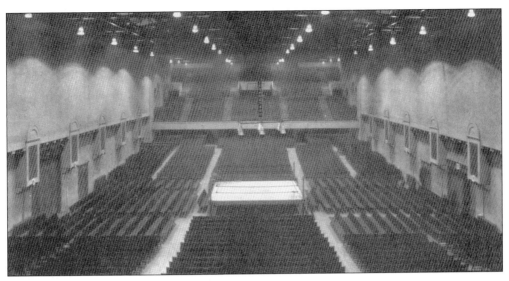

The North Wing of Music Hall was used for several sports. The boxing ring was of the same construction as the ring in New York's Madison Square Garden and was equipped with nine 1000-watt lights. An electronic round announcer above the ring signaled the progress of the bouts. Dressing rooms and showers were on the second floor. One of the local boxers who appeared in Music Hall was featherweight champion Freddie Miller. Born Frederick Mueller in Cincinnati in 1911, Miller had many of his early professional fights in this venue. He won a portion of the featherweight belt in 1933 in Chicago and then unified the championship on September 21, 1934, by defeating Nel Tarlton in England. Over his career, Miller fought more than 230 times and after his retirement became an outstanding golfer, bridge player, and ballroom dancer.

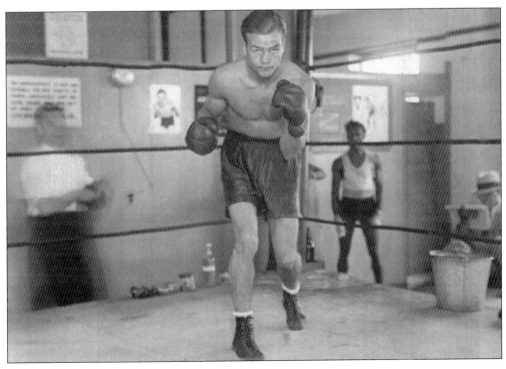

Early in the design process for Music Hall, friction arose between the musical and exposition factions. This dispute prompted Rueben Springer to contribute an additional $50,000 for construction of two wings flanking the central auditorium. Since then, the North and South Wings have hosted a wide variety of events from national political conventions to auto shows, as seen in this 1920s image.

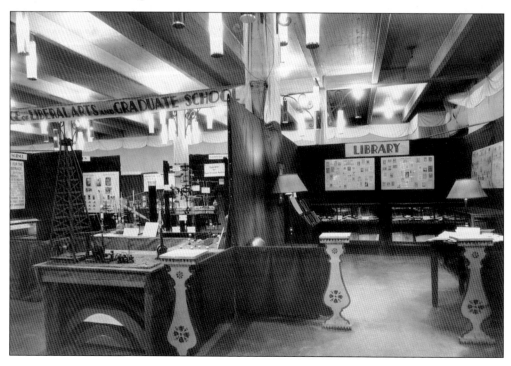

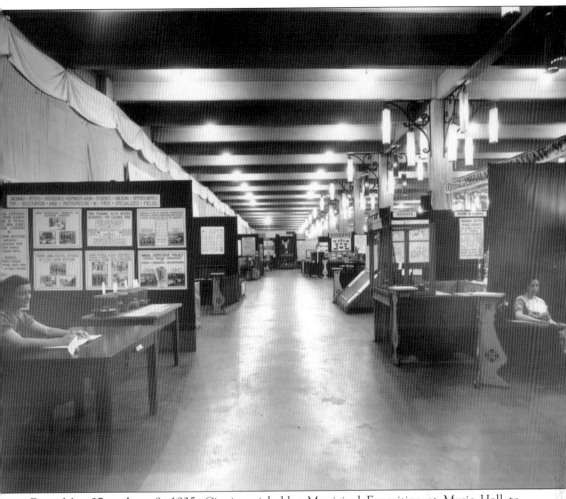

From May 27 to June 9, 1935, Cincinnati held a Municipal Exposition at Music Hall to promote the urban services provided to Queen City residents. One area of the exposition featured displays by local educational organizations, including the public library, the Cincinnati Historical Society, Xavier University, and Hebrew Union College. In these two photographs (above and opposite bottom) are seen the exhibits created by the University of Cincinnati to promote their colleges of liberal arts, business administration, household administration, and the graduate school—pointing out the symbiotic relationship between a municipal university and the city it serves. In the UC library display, posters featuring "Book Plates of State Universities" and "Book Plates of Ohio" were displayed.

As the subway continued its construction, a number of problems surfaced, the least of which was the finagling and bickering between politicians. Engineering plans did not take into account the closeness of buildings next to the canal, and the excavations soon caused structural damages. The photographer assigned to the project quickly found himself with another task: document the damage in preparation for claims made against the city by building owners and residents. In the interior of a house at 2501 Addison Street in 1927, the owner stands in a bedroom as the photographer shoots away. Arrows indicate cracks in the ceiling.

At 2883 McMicken, cracks are noted in the ceiling of a rear room on the second floor—the side of the house that faces the subway bed. The historical value of such images is the documentation of household life during the 1920s: a picture of President Warren G. Harding hangs on the wall above the family piano. A framed "Last Supper" hangs above the bed.

In another home on McMicken
Avenue, the photographer
inadvertently captures his own
image in a hallway mirror.

Cracks from the construction just
yards away appeared in the kitchen
of a home at 2941 McMicken. As
with the other photographs, the
cameraman recorded it precisely:
June 16, 1927, 11:35 a.m.

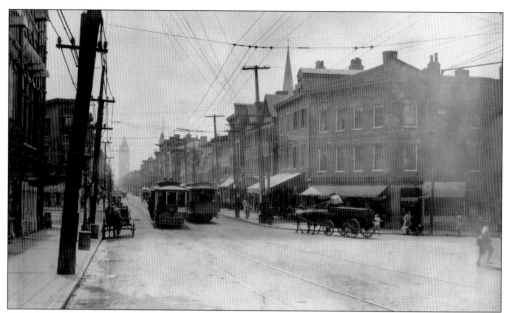

As the subway entered the mix of urban transportation, it still vied with other means of passenger movement. This image of Liberty Street shows the street railway trolleys sharing the road with horse-and-wagons in the early 1920s. By 1927, Mayor Murray Seasongood decided the subway construction had caused enough problems so he ended the project. In the end, divisive Cincinnati politics had very little to do with the subway's demise. The rising automobile culture, engineering problems, and increasing damage claims that would have bankrupted the city were the reasons the subway never became a reality.

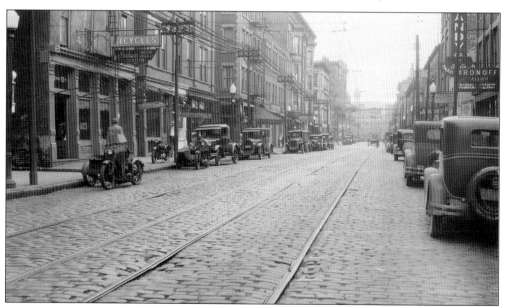

On West Twelfth Street, looking east from Race Street, transportation seems a bit more contemporary in 1929. A motorcycle dealer on the left side of the street offers Indian Motorcycles for sale, while on the right side, automobiles park at the curb in front of the George Ast Candy Company.

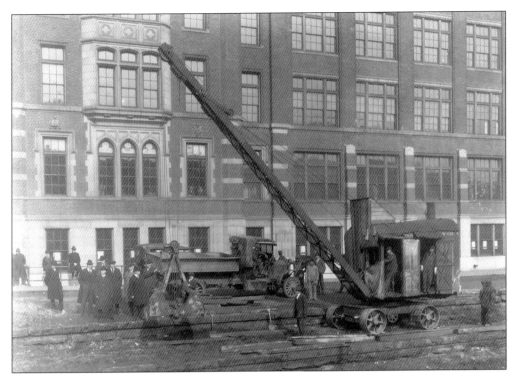

With the demise of the subway plan, efforts were turned to building a permanent roadway that would wind downtown over the old canal bed. Here in front of the Ohio Mechanics Institute, a steam shovel and dump truck are brought in to begin grading of the road bed as city officials stand by.

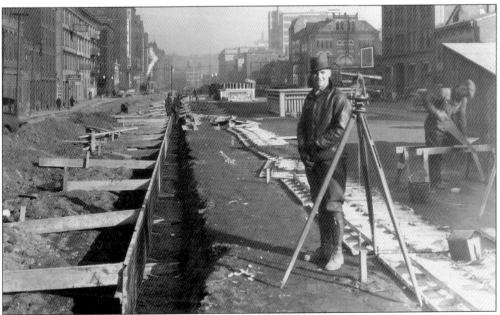

Along the north side of the parkway, east from Race Street, a surveyor poses for the photographer. Steel forms are put into place for a wall along the north side.

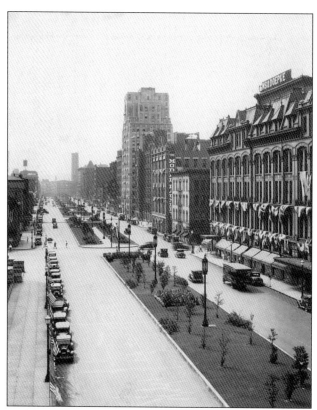

Finally completed! The new Central Parkway was dedicated over a span of three days, from October 1 to 3, 1928. At a cost of over $4 million, the boulevard ran for four and a half miles from Broadway Street downtown to Ludlow Avenue at the northern foot of Clifton. The American Building stands prominently in the center of this photograph. It was designed in the Art Deco style by the firm of Joseph Steinkamp, who was a descendant of the builder of Old St. Mary's Church.

Before the new Parkway was completed, one could drive to the Hamilton County Courthouse and park all day for 25¢.

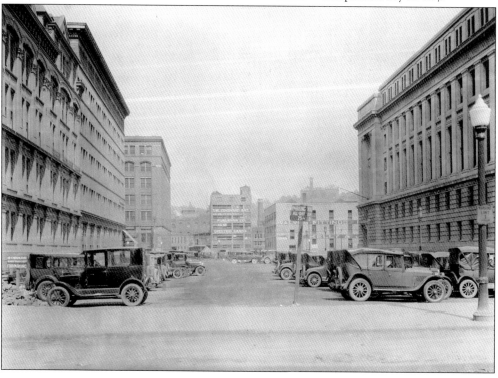

The Strobridge Lithography Company moved to this site on the canal in 1884. At the time, the company was a leading producer of circus, theatrical, and outdoor advertising posters. A fire destroyed the plant in 1887, but it was quickly rebuilt. In 1891, a New York office was opened and began producing theatrical bills, the most famous of which were those designed by Alphonse Mucha for Sarah Bernhardt's 1896 American tour.

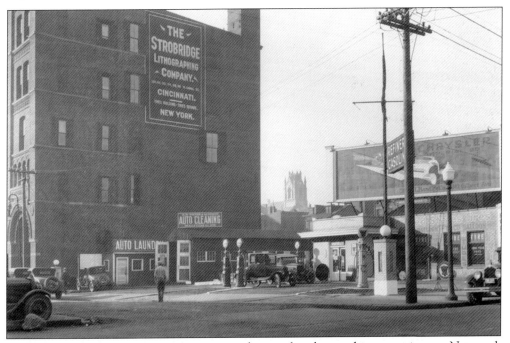

By 1925, Strobridge outgrew its quarters on the canal and moved its operations to Norwood, except for the poster division seen here beside the newly constructed Central Parkway. The Strobridge family sold the business in 1961, and it closed a decade later. A gas station with an early car wash, called an "auto laundry," occupies the corner.

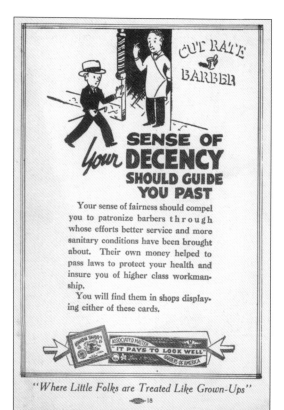

SENSE OF
Your DECENCY
SHOULD GUIDE
YOU PAST

Your sense of fairness should compel you to patronize barbers t h r o u g h whose efforts better service and more sanitary conditions have been brought about. Their own money helped to pass laws to protect your health and insure you of higher class workmanship.

You will find them in shops displaying either of these cards.

"Where Little Folks are Treated Like Grown-Ups"

In 1936, unionized barber shops were commonplace in Cincinnati. In this promotional flyer for the Barbers' Union, patrons were encouraged to show a measure of decency—and concern for their appearance—by only using union barbers.

In a show of community support, the local union barbers often brought scissors, clippers, and combs to neighborhood schools to give the students a free trim. The improvised barber chairs look a bit unsteady, however. Presumably, no one lost an ear, and they all went home to their families in tonsorial splendor.

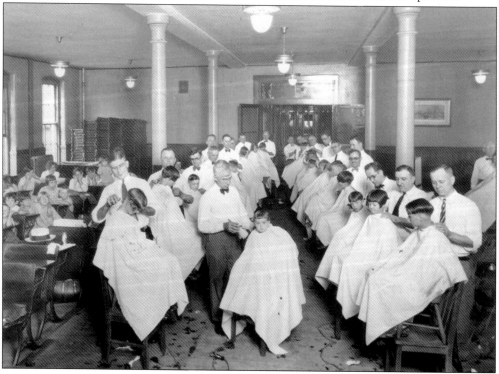

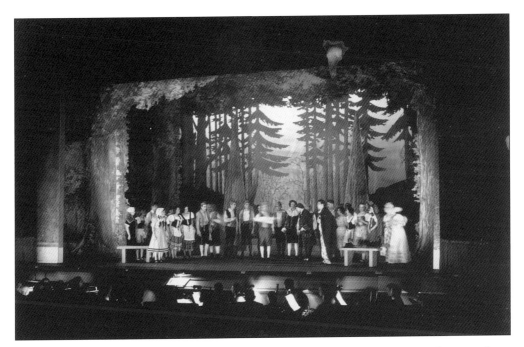

Emery Theater at the Ohio Mechanics Institute became a community venue for everything from the Cincinnati Symphony Orchestra and University of Cincinnati productions to traveling German language theater and, a decade later, the productions of the Federal Theater Project during the Depression. OMI students also took advantage of their school's remarkable theater, however. In these images, Scene II from *The Fortune Teller* is shown on the Emery stage in the top photograph, while in the bottom photograph is seen part of the cast of *The Charm School*, presented by OMI students on March 17, 1926.

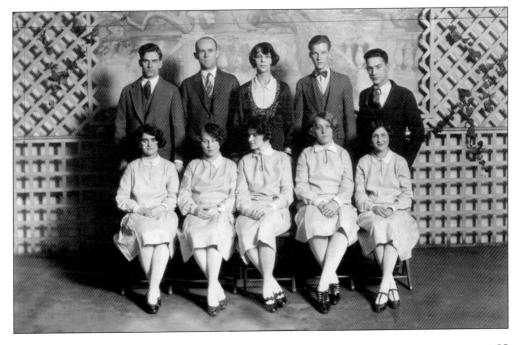

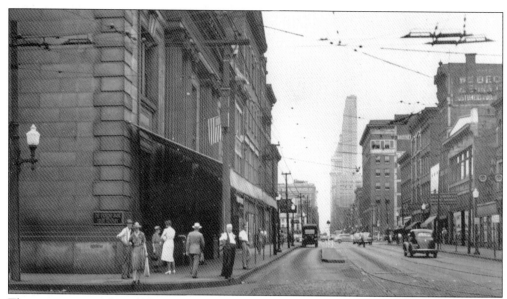

The intersection of Twelfth and Vine Streets had long been an area known for its vice and corruption. In the 1890s, 23 saloons were located on the single block between Twelfth and Thirteenth. Taken in 1944 by the Highway Engineering Department, this photograph shows a rehabilitated business district and recently improved streets.

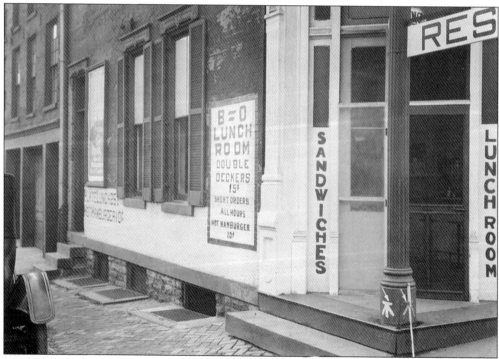

The documentation of damage claims against the subway project continued as the highway department worked to make improvements. The arrows in the lower right corner point to damages claimed by the B & O Lunch Room, located on the southeast corner of Walnut and Central Parkway. The photographer took visual note of the claims on September 18, 1926.

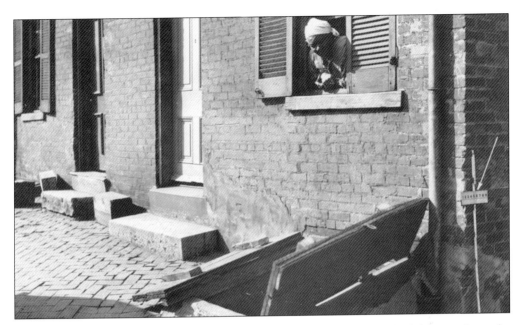

Over-the-Rhine residents look out at the photographer making a record of damage claims for their tenement buildings. In the top photograph, taken in October 1926 at 22 W. Canal on the corner of Central Parkway and Baldwin Alley, a folding measure is used against the wall. In the bottom photograph, taken the following March, children at the Streitmann Building on Central Parkway gather beside the steps leading to the basement.

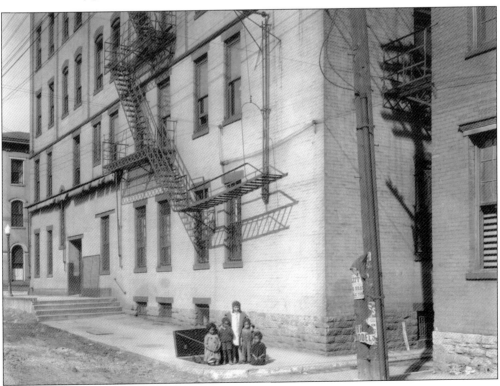

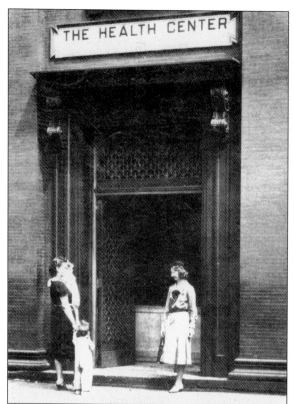

By the late 1930s, the city was making more of a concerted effort to address the health needs of Over-the-Rhine residents. Migrants from Appalachia began to arrive in larger numbers, and the migration would only increase in the years of World War II and the post-war period. In 1938, Carl A. Wilzbach was appointed as Commissioner of Health following a period of five years in which there was no direction or coordination of health matters. At 212 W. Twelfth Street, a new health center was established where immunizations and dental care was provided, and testing was done for communicable diseases, especially syphilis and tuberculosis. In 1938 alone, over one thousand patients were treated for syphilis. Neighborhood children were also examined on a frequent basis for tuberculosis, shown in the photograph here.

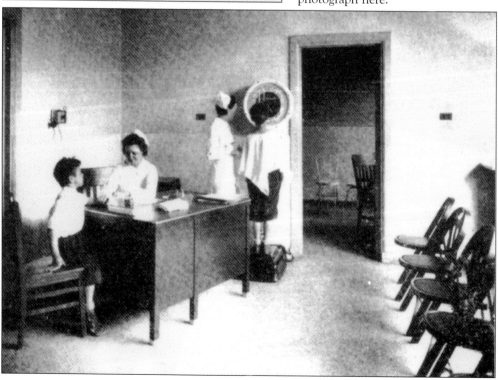

Four

STRUGGLES WITH IDENTITY, ETHNICITY, AND POLITICS: 1946–1970

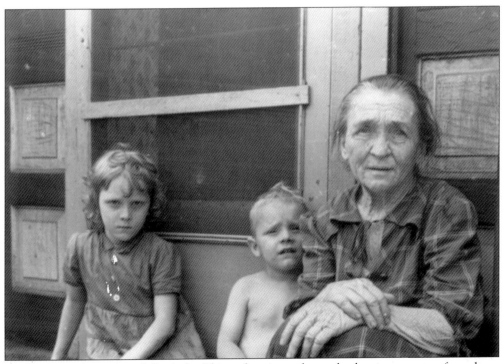

In the 1940s, sections of Over-the-Rhine deteriorated greatly, leaving streets of rundown tenements as the only affordable housing for Appalachian migrants. Documentary photographer and civic activist Danny Ransohoff chronicled the poverty of the neighborhood in a series of strong images.

With the burgeoning Appalachian population in Cincinnati, particularly in Over-the-Rhine, city leaders knew that concerted planning and social programs needed to be developed. There was a considerable culture shock both for longtime urbanites and the new arrivals. Customs and traditions were different, attitudes were dissimilar, and for the Applachians settling in Over-the-Rhine, poverty, unemployment, and lack of education were immediate concerns. Dr. Roscoe Giffin, a Berea College sociologist who specialized in Appalachian studies, was brought to Cincinnati in 1954 to address the issues. (Photograph courtesy of Berea College Archives.)

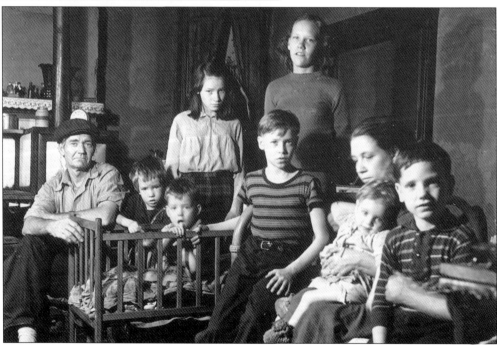

Giffin's visit was sponsored by the Mayor's Friendly Relations Committee. His purpose was to lead a workshop to foster understanding by city agency and service workers of the particular needs of Appalachians. Giffin began with facts: as of 1950, there were more than 375,000 migrants from West Virginia and Kentucky who lived in Ohio, most of them in the state's major cities. (Photograph by Daniel Ransohoff.)

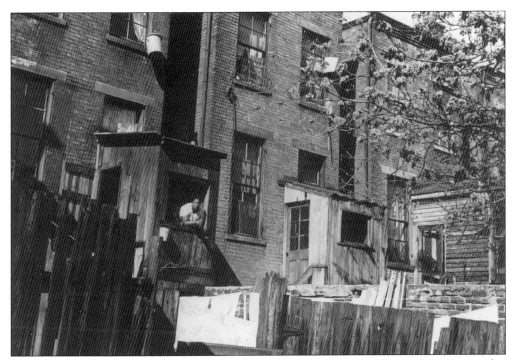

The workshop discussed the overcrowded living conditions in Over-the-Rhine, often ten or twelve people in two rooms, in slum conditions with no modern facilities. Rents were high, leading to many relatives moving in together to pay expenses. (Photograph by Daniel Ransohoff.)

Living quarters were obtained wherever they could be gotten. What helped maintain the migrants were strong family ties and an attempt to hold on to their mountain traditions in the face of a much different geographical environment. They were aware of a strong prejudice against them and found it difficult to adjust to the pace and competition of the city. (Photograph by Daniel Ransohoff.)

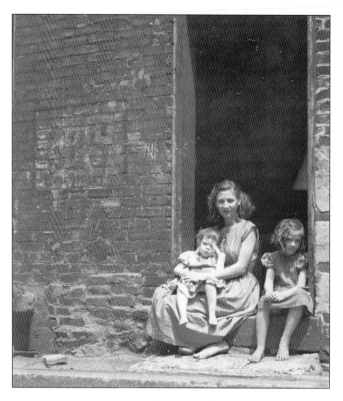

One problem Cincinnati social service workers pointed out in Giffin's workshop was that Appalachians seemed to hold little value for formal schooling. The children often had health problems that made it difficult to adjust to large schools and the pressures of learning, and though they had the ability to learn, they lacked the cultural patterns of consistent education. Adults did take great pride in their children's school records, but because they sometimes felt ashamed of their own lack of education, they did not pressure their children to attend and they viewed the school authorities as threatening. (Photograph by Daniel Ransohoff.)

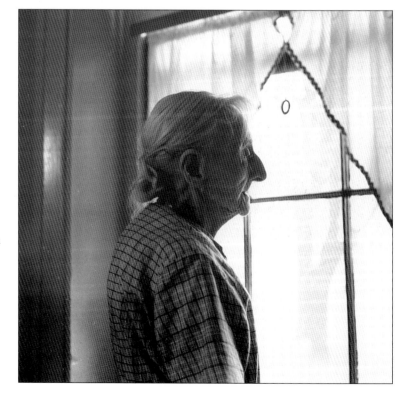

Though Appalachians often felt bewildered, lost, and resentful, they maintained a strength of individualism and reliance on their family cohesion. (Photograph by Daniel Ransohoff.)

Children missed the activities of the country, but were more adaptable to city life than their parents. However, they became used to doing as they pleased because often they were on their own. Their mothers and fathers were out of the house getting work wherever they could. Giffin cautioned in his workshop, published as *Report of a Workshop on the Southern Mountaineer in Cincinnati*, that the findings and discussions did not constitute adequate treatment. However, the groundwork was laid, he believed, for the city to take the necessary actions. (Photograph by Daniel Ransohoff.)

BOXING

PARKWAY ARENA COURTESY PASS
ADMIT ONE
Good Only Night of
WEDNESDAY, AUG. 9

This Pass when Presented at Box Office with Payment of 25 Cents
Service Charge will Entitle Bearer to One Ringside Reserved Seat

Signed Parkway Arena

79 CENTRAL PARKWAY AND FINDLAY STREET

The Parkway Arena was an outdoor wrestling and boxing venue, located at 1718 Central Parkway at the corner of Findlay Street. The open-air arena had a floor below street level and eight-foot high fences surrounding it to offer some small resistance to non-paying fight fans. Ross Leader, the arena's promoter and matchmaker, brought in Cincinnati's top boxers in the 1950s and '60s. By the late 1960s, when the Findlay Market area was undergoing renovation, Parkway Arena's days were numbered. It was demolished in 1968.

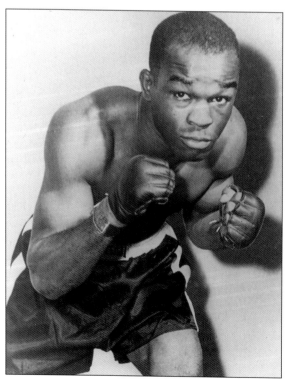

Wallace "Bud" Smith was another of Cincinnati's boxing champions. His professional career began at Music Hall on November 29, 1948, when he KOed Torpedo Tinsley in the first round. He then went on to win his next seven fights. Bud Smith's first sixteen bouts were battled in Cincinnati, most of them at Music Hall or the Parkway Arena. On June 29, 1955, he won the lightweight title over Jimmy Carter. His career record was 31-23-6. In 1973, he was killed while trying to rescue a woman from being assaulted.

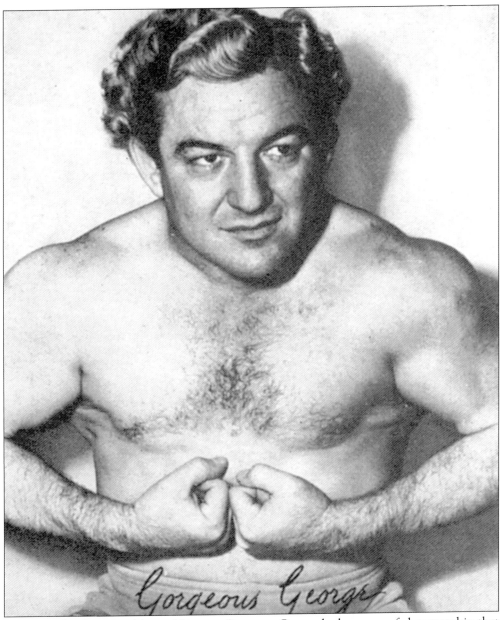

Gorgeous George

The most flamboyant athlete of his era, Gorgeous George had a sense of showmanship that transcended the wrestling ring and influenced athletes into the current era. He often came to Cincinnati on the professional wrestling circuit to grapple at Music Hall and Parkway Arena. Born in Nebraska in 1915 as George Wagner, he had little success initially until he developed the gimmicks that would make him a household name in America. He grew his hair long, dyed it platinum, and pinned it with gold-plated bobby pins. He wore garish robes and never entered the ring until one of his "valets" sprayed it with perfume. He affected an effeminate air, and then proceeded to cheat as much as he could, rousing the Music Hall fans to ear-splitting boos and laughter. In the dawning of the television era, Gorgeous George did more for his "sport" than any other wrestler and set the pattern for professional wrestlers' personas today, in addition to every other athlete seeking to capture the public's attention. Gorgeous George died in 1963.

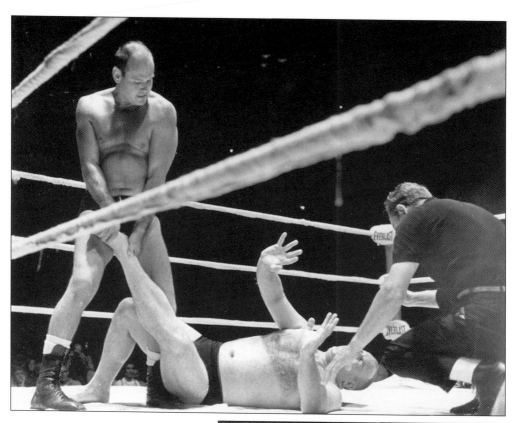

In the summer of 1954, Marilyn Sheppard, the wife of a successful Cleveland physician, was brutally murdered. Sam Sheppard was indicted and tried for his wife's death, his first conviction overturned in a later trial on appeal. But his medical career was ended, and the case became legend in the United States. A trained athlete, Sheppard turned to professional wrestling, at first in charity matches, but then to make a living. One of his early moves was to insert two fingers into his opponent's mouth and press down on the mandibular nerve underneath the tongue. His rivals screamed in pain. Traveling the circuit of tag teams and histrionics, Sheppard often wrestled at Music Hall. (Photos by Jack Klumpe.)

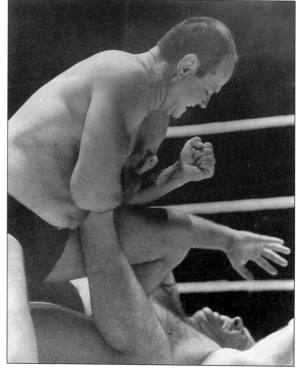

Another boxer who fought a lot at Music Hall was Ezzard Charles, one of the great heavyweights of all time and one of the hardest punchers. His bouts with Rocky Marciano are legend in boxing history. Known as the "Cincinnati Cobra," Charles fought as a young amateur in Cincinnati, continued boxing in the Army, and pursued a professional career after his discharge. In 1949, he beat Jersey Joe Walcott for the heavyweight title and retained it the next year against Joe Louis. The fights with Marciano were intense slugfests, particularly the 1954 contest. Although he was defeated, Charles assured himself a place in boxing lore. The top photograph shows Charles at a 1948 weigh-in at the old Times-Star gym on Eighth and Broadway. (Photograph by Jack Klumpe.) The other image is of a cover of *Ring Magazine* in 1948, promoting Charles for a shot at the title.

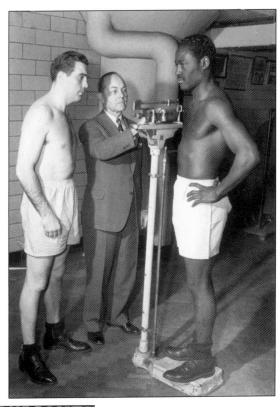

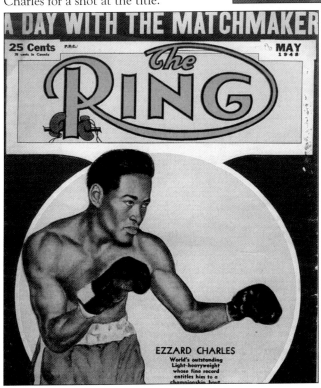

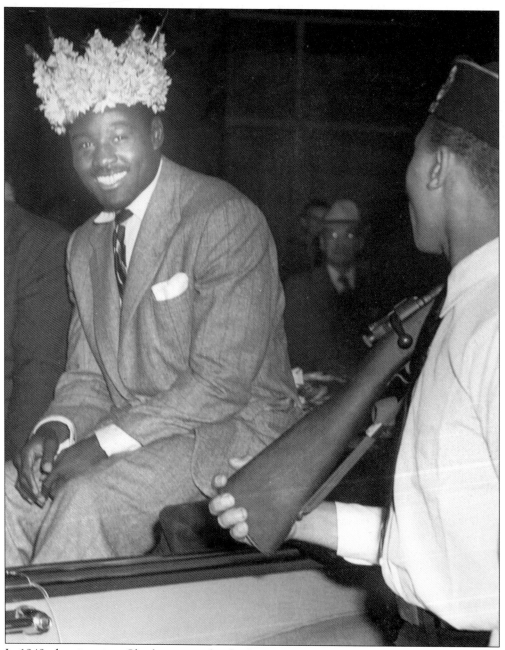

In 1949, the victorious Charles returned to his hometown in glory. Greeted at Union Terminal, he was given a crown and an honor guard for a parade that wound its way through the West End, Over-the-Rhine, and downtown. In later years, the street leading from Union Terminal was named in his honor. (Photograph by Jack Klumpe.)

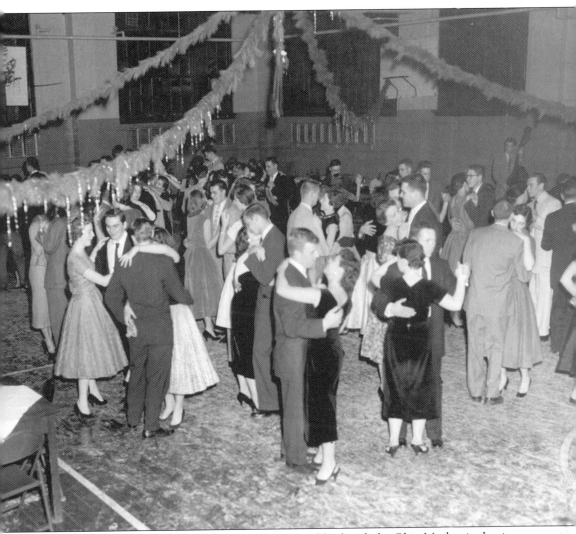

In marked contrast to the decay of the surrounding neighborhood, the Ohio Mechanics Institute stood on its edge in stolid respectability. The students continued to enjoy their educational experience in all its forms, as shown in this photograph of the 1956 Christmas Dance.

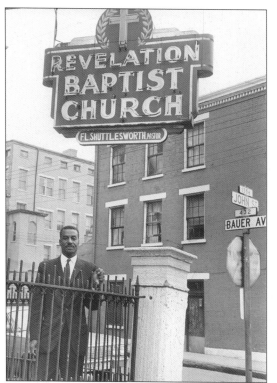

The 1960s fostered an increased social activism that was led by neighborhood ministers who viewed the tenets of religious faith as grounded in social justice. One such leader was Baptist minister Fred Shuttlesworth. Reverend Shuttlesworth had worked with Martin Luther King in the Birmingham, Alabama, civil rights protests, and in his church in the West End, shown here in 1965, he attracted a congregation from Over-the-Rhine who followed his call for social and political awareness. (Photograph by Jack Klumpe.)

In the 1940s through the 1960s, prejudices between African Americans and Appalachians were quite strong, though children were often more accepting of one another than their parents were. (Photograph by Daniel Ransohoff.)

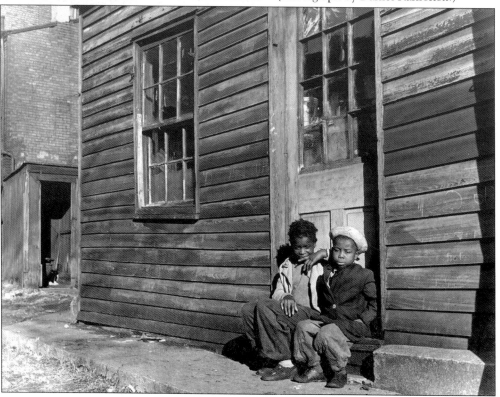

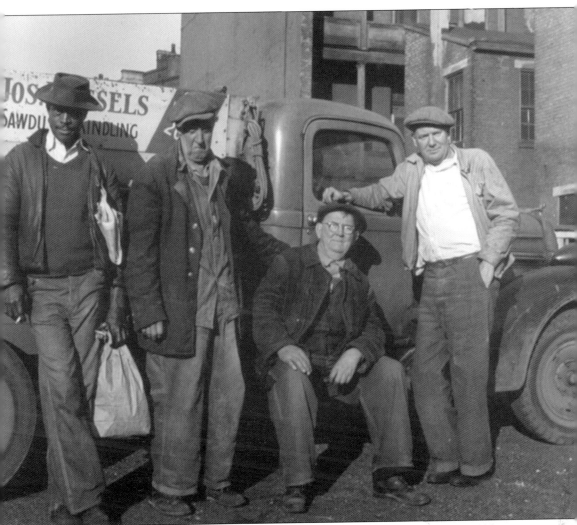

The decades after World War II still found unemployment to be one of the largest problems in Over-the-Rhine. What work could be found tended to be day labor, and did little to break the poverty cycle. (Photograph by Daniel Ransohoff.)

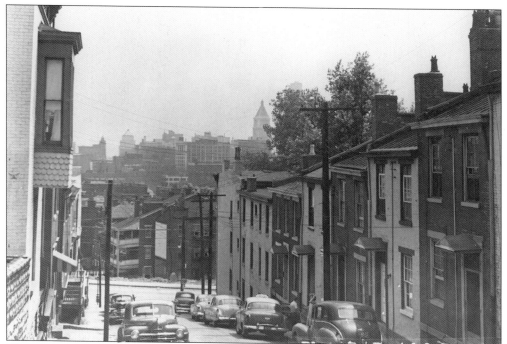

Though his focus was documenting the need for social action in Over-the-Rhine, Ransohoff's camera also captured the charm of the stair-step houses with covered stoops and chimney pots. The double-tiered sleeping porches on the house at the bottom of the street emphasized that this was still a neighborhood of families.

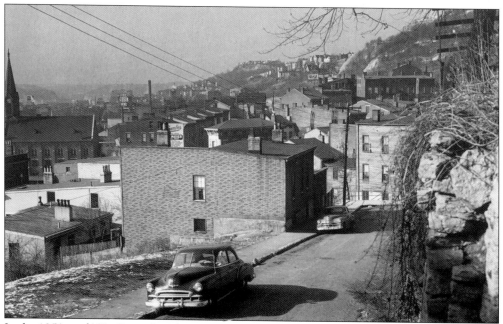

In the 1950s and '60s, Over-the-Rhine could still be viewed with a sense of its urban architectural appeal. From this image taken in the street above breweries and homes, the Phillipus Church of Christ with its hand pointing toward heaven can be seen at the left.

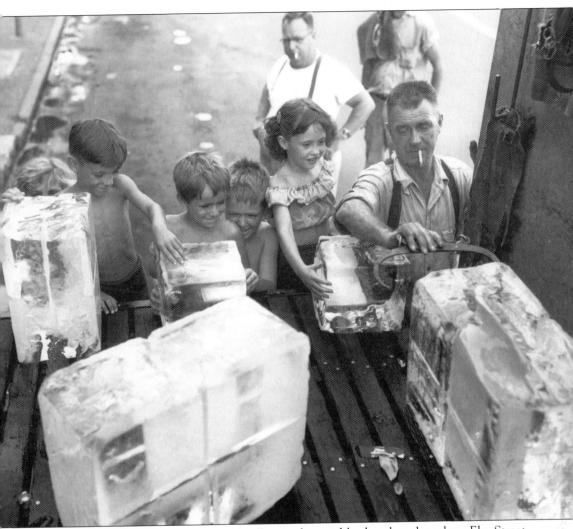

As late as the 1950s, many apartment dwellers in the neighborhood, such as these Elm Street kids "helping" the iceman, depended on the blocks for home refrigeration. (Photograph by Jack Klumpe.)

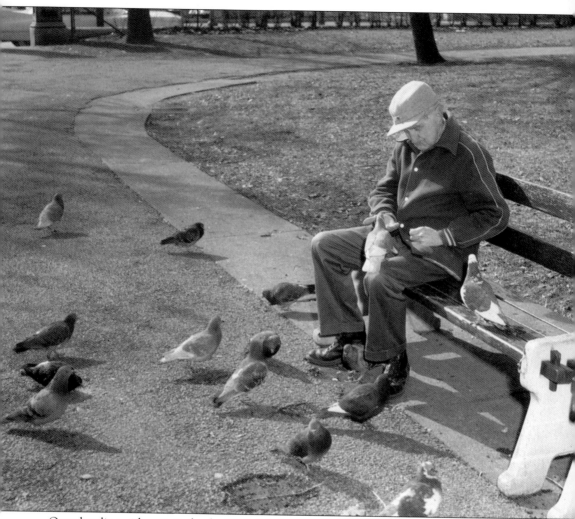

Once bustling with activity, by the 1960s Washington Park presented a vastly different experience for an elderly man feeding pigeons. Gone were the families with picnic baskets and bands playing German waltzes. The park became dilapidated and unwelcoming. By the 1980s, however, a rebirth was underway that again attracted neighborhood events. (Photograph by Jack Klumpe.)

"Mr. Spoons" was a neighborhood character in the 1950s and 60s when Over-the-Rhine was the northern home for mountain people from Appalachia. The German beer gardens and saloons had long since been replaced with bars and honkytonks, and everyone knew Mr. Spoons. Moving from bar to bar over the course of the evening, he would join the live bluegrass and country bands, rapping out the rhythms on the taped and bent spoons he carried with him. Here Mr. Spoons is shown hanging out at Aunt Maudie's Tavern on Vine Street.

By the 1960s, community advocacy groups were working to preserve the Applachian traditions brought to the city by staging Appalachian Week, Appalachian Festivals, and other community events that raised awareness of this new urban heritage. Music, traditional crafts, and job fairs were part of the celebrations. In this view, Mr. Spoons again performs before an appreciative crowd.

Five

REVITALIZATION AND SOCIAL ACTION:
1971 TO THE PRESENT

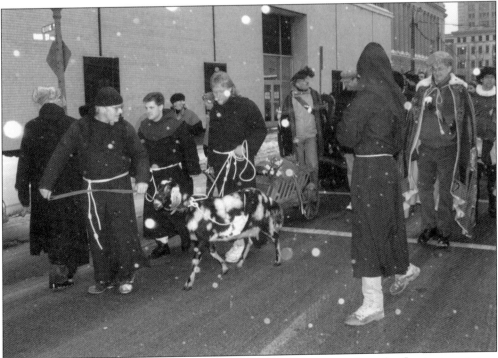

A Cincinnati BockFest parade will go on no matter what—even when the flurries turn into a heavy snowfall. The BockFest goat pulls a cart holding the ceremonial first keg of bock beer. Spring *has* to be around the corner.

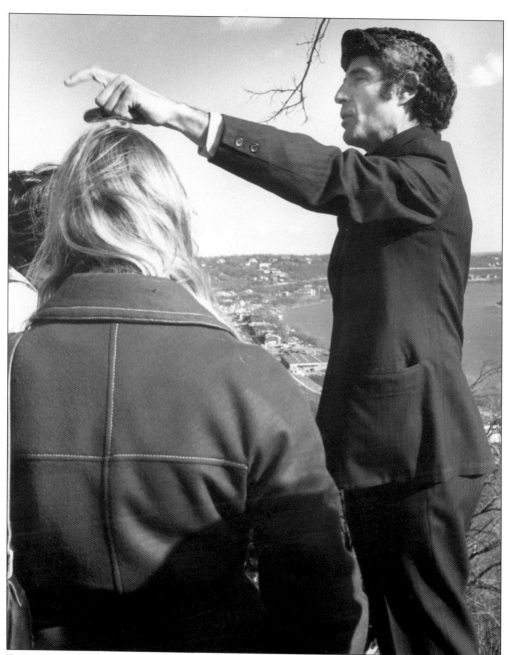

Danny Ransohoff (1921–1993) was a Cincinnati original. A native of the city, Ransohoff spent most of his life documenting its streets and people and working as a housing and social services advocate. Ransohoff was tireless in his promotion of the city's virtues and equally determined to eliminate its problems. Over the decades, his documentary photographs were widely exhibited and used in publications to solicit aid for the poor. Much of his work was done for the city's Better Housing League, and his Over-the-Rhine photographs had an uncommon immediacy to them. While working for the Community Chest, Ransohoff also taught urban politics classes at the University of Cincinnati and often gave tours of the city, as seen in this 1971 view of him with a UC faculty group.

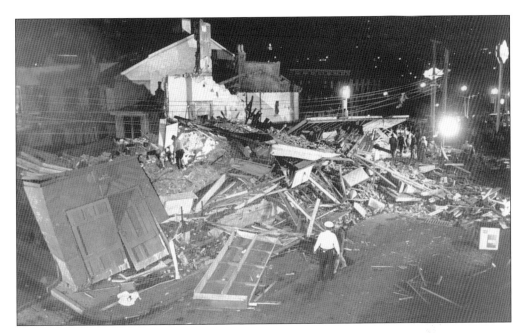

Newspaper photographer Jack Klumpe snapped pictures of Cincinnati people in events for nearly four decades. Often his work took him to Over-the-Rhine, where on March 31, 1973, he photographed the results of an explosion at the corner of Elm and Wade Streets. The massive blast killed 7 people and injured 19. Klumpe's documentation was important because he created a visual record of the neighborhood in the 1960s and 70s. Beyond the city planning, beyond street repairs or architectural renovation, there were real lives being lived, with all the tragedies that sometimes accompany them. (Photos by Jack Klumpe.)

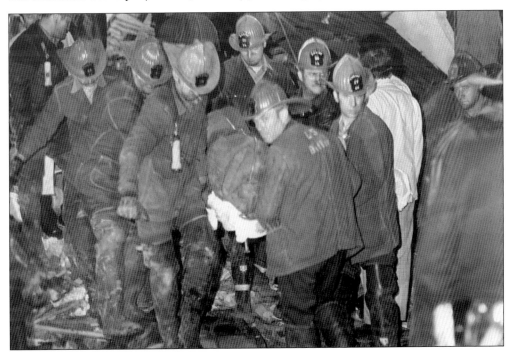

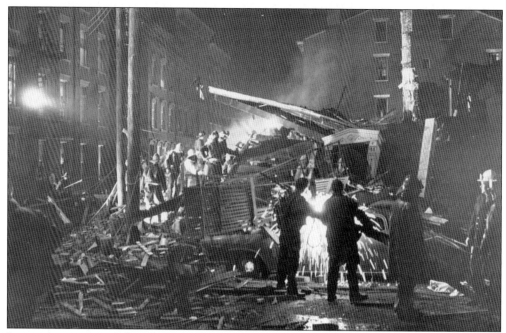

In another instance, the photojournalist again was a graphic witness to an explosion and resulting fire that decimated the homes of the residents. (Photograph by Jack Klumpe.)

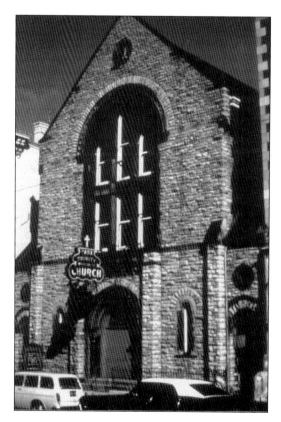

Wilhelm Nast emigrated to America in 1828 and arrived in Cincinnati a few years later. He organized German Methodism in Ohio and founded *Der Christziche Apologette* in 1839, serving as editor of the journal for fifty years. The Nast Trinity Methodist Church was organized in 1835, and this building at 1310 Race Street was constructed in 1880, serving Over-the-Rhine Methodists for over a century.

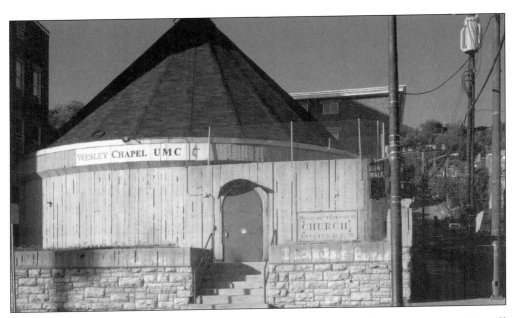

In 1999, urban documentary photographer Fred Scruton began shooting pictures of small churches in the core of America's cities. The Brooklyn-based photographer traveled to Cincinnati and visually recorded how these churches became part of a colorful urban landscape. The top photograph is of the Methodist Wesley Chapel at the corner of East McMicken and Walnut Streets. The bottom image is of an exterior wall mural for a storefront church at the corner of West McMicken near Ravine Street. (Photos courtesy of Fred Scruton.)

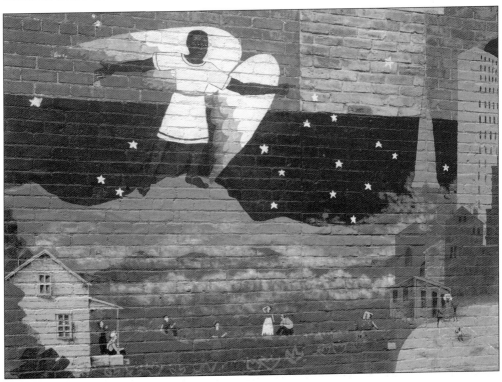

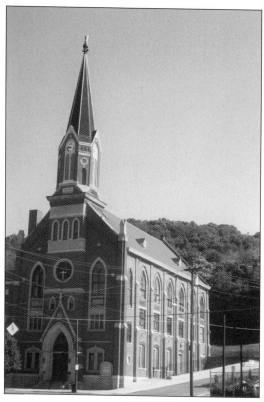

Phillipus United Church of Christ rises high over the neighborhood at the northern edge of Over-the-Rhine. The church, at 106 W. McMicken, has a steeple that can be seen for blocks around, its pointing hand to the sky serving as a local landmark. Founded in 1890 by Jacob Pister, the church's congregation descended directly from the first German church in Cincinnati. It was dedicated in 1891, and the Moerlein brewing family donated an organ that is still in use. In 1923, the congregation joined the Evangelical Synod of North America, and in 1958, it joined with the United Church of Christ denomination. Today, the church is often in the forefront of social activism in the neighborhood to provide housing and care for the poor.

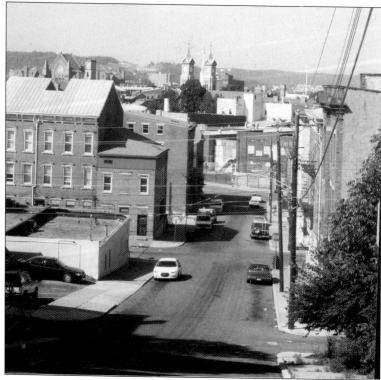

Over-the-Rhine is viewed from the height of Mulberry Street. The spires of St. Francis Seraph Church can be seen in the distance.

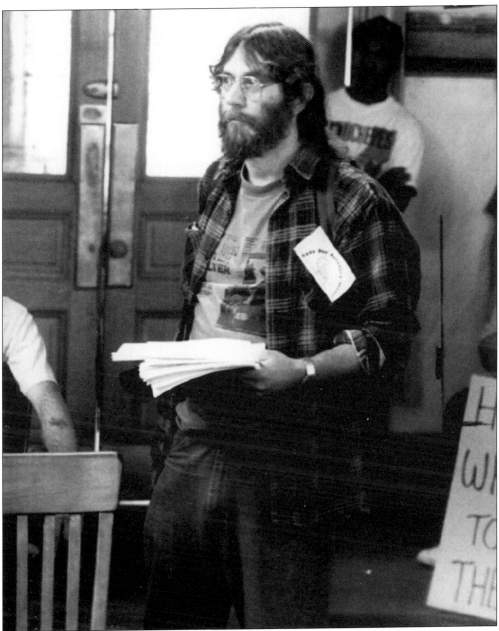

Stanley "Buddy" Gray was an absolutely fearless advocate for the homeless and poor in Over-the-Rhine. A national leader for tenant rights and providing for the homeless, Gray's style was, to put it fairly, confrontational in making landlords and city officials take notice of the residents. He was a lifelong activist who helped found the Drop-In Shelterhouse for the Homeless, directed tutoring for area children, and organized tenant's rights groups. His work was honored in 1997 when he received the Martin Luther King Lifetime Achievement Award, and though he had as many foes as friends in his approaches to Over-the-Rhine, no one could deny he was a man of convictions. On November 15, 1996, Buddy Gray was shot to death by a mentally ill man whom he had helped. Today his work carries on through the Greater Cincinnati Coalition for the Homeless. (Photograph by Jymi Bolden.)

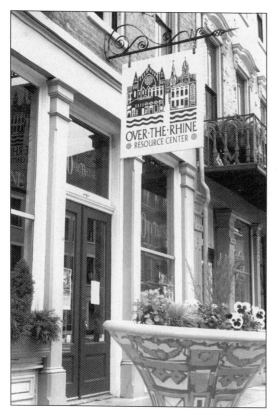

The Over-the-Rhine Resource Center was founded in 1994 with the purpose of assisting investors in revitalizing the neighborhood economically and architecturally. Additionally, they had the goal of providing a social integration through renewed interest in the neighborhood's possibilities. Today they provide information on building regulations and promote home-buying and commercial development. Their efforts have led to a renaissance of Main Street, with art galleries, loft space, and a nightlife of clubs and restaurants. In the block across the street from the Center, the Japps bar and restaurant is in the same building as the original Japp's—a nineteenth century business of wigs and hair pieces.

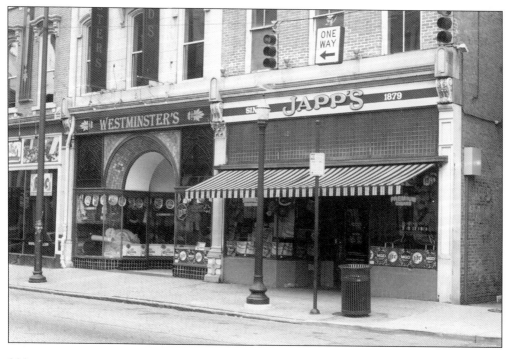

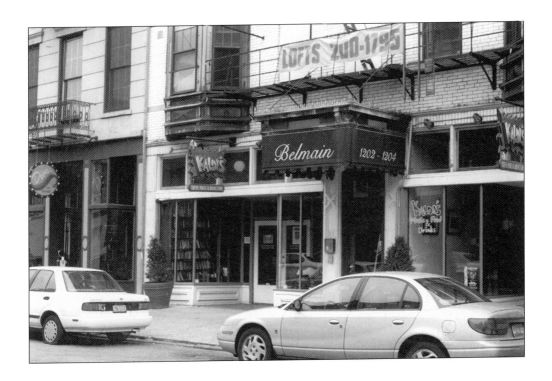

Two other vibrant businesses that came along to revitalize Main Street were Kaldi's Coffeehouse and the nightclub Jump. The club attracts a college crowd, while the food, coffee, and beers of Kaldi's brings in a lunch and dinner trade. Kaldi's interior is lined with shelves of used and out-of-print books for sale.

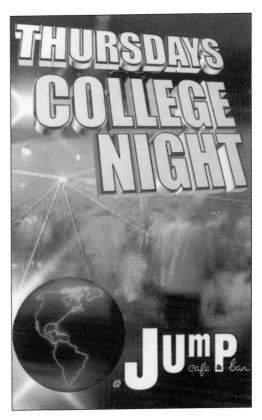

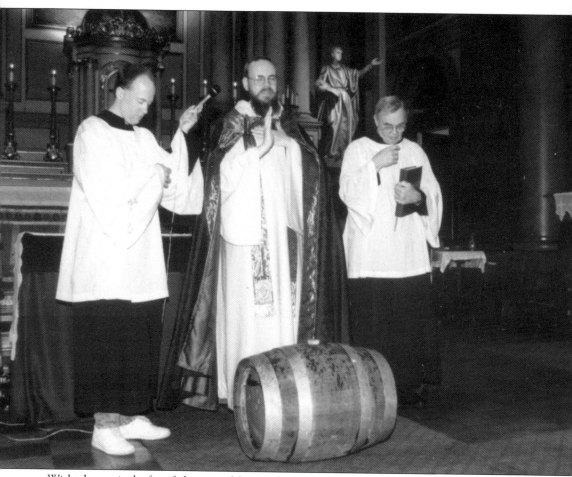

With the revival of craft beers and beer pubs in America in the 1980s, Cincinnati followed suit with a revival of German beer customs in Over-the-Rhine. In this photograph from March 1996, the priest at the historic church of Old St. Mary's confers his blessing on the first keg of Hudepohl Brewery's seasonal bock beer. After the blessing, a parade of beer kegs, goat carts, monks, and revelers wove their way down Twelfth Street.

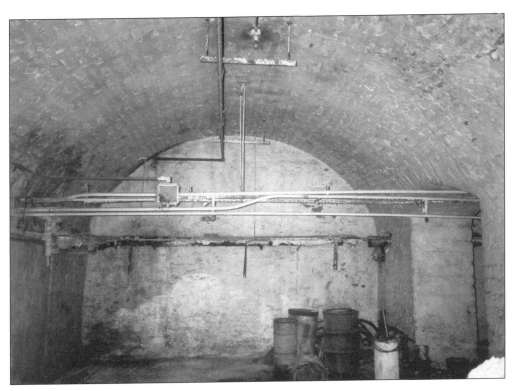

Across the neighborhood, back on Central Parkway, the old Windisch-Muhlhauser brewery, which became the Burger Brewery in the 1930s and then was purchased by the Hudepohl Brewery, was about to be demolished in the 1980s. The massive, classic German brewery architecture of the structure would disappear. On a lark one day, the authors talked their way into a tour of the limestone cellars for some last glimpses at a monument to Cincinnati's beer heritage.

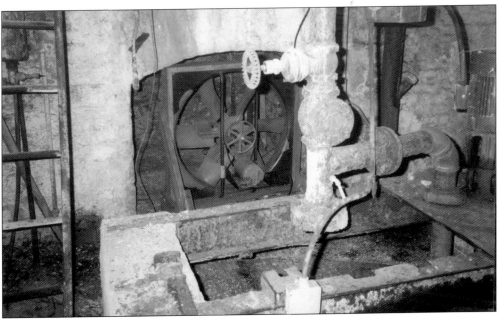

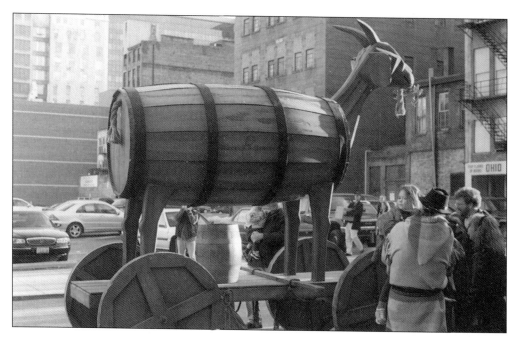

The days of Cincy beer enjoyment continue, however. The 11th Annual BockFest was held on March 7 and 8, 2003, to celebrate the coming of spring. The festivities mark Cincinnati's German roots and the brewing of bock beer during the Lenten season. "Bock" is the German word for goat, and tradition has a goat-drawn cart pulling the first keg of the beer to be blessed. The parade began in front of Arnold's Bar & Grill on East Eighth Street, one of the oldest taverns in the city. Monks, dogs, and assorted groups began their march up Main Street, around Melindy, and south on Clay to Twelfth, where Mayor Charlie Luken issued a proclamation to begin the two days of revelry, gallery exhibits, and, of course, an accompanying SausageFest at the historic Grammer's Restaurant on Walnut Street.

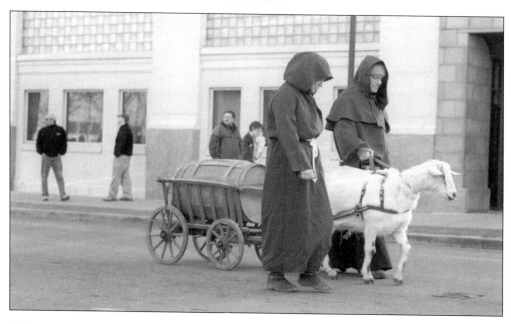

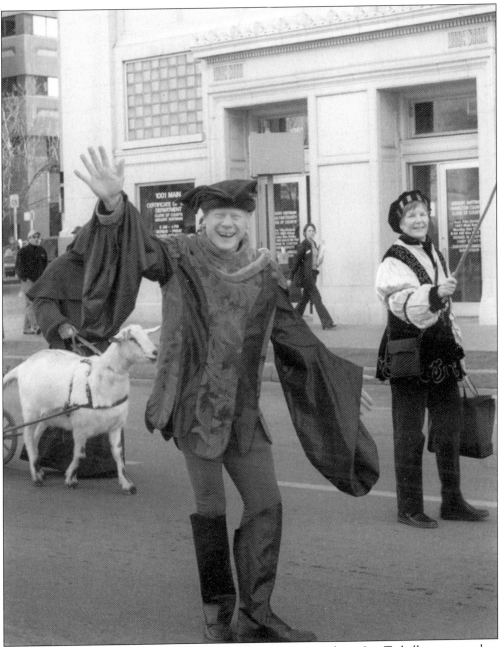

The Grand Marshal for the 2003 parade was Cincinnati councilman Jim Tarbell, never at a loss for celebrations and costumes. A longtime resident and businessman in Over-the-Rhine, Tarbell has been very vocal in his support of rehabilitating the neighborhood both architecturally and socially. When the Cincinnati Reds desired a new stadium to replace Cinergy Field (born Riverfront Stadium), Tarbell spearheaded a drive to build a new ballpark, which he called Broadway Commons, on the eastern edge of Over-the-Rhine. The hope was that neighborhood businesses and homes would benefit from the association. The decision ultimately was made to build a new ballpark on the river again, Great American Ballpark, but Tarbell continues to be a strong advocate for the traditions and potential of Over-the-Rhine.

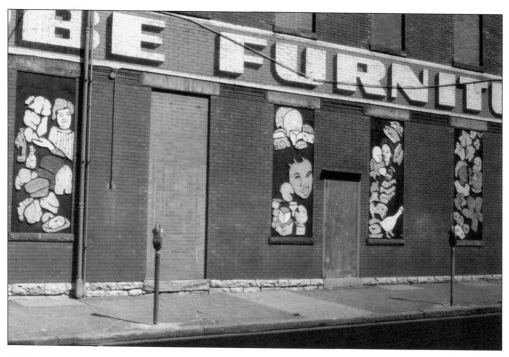

In the area around Findlay Market, wall murals exhibit themes of food. Urban wall art has given Over-the-Rhine a colorful expression of community customs and patterns.

The murals are a form of neighborhood folk art that reveals the lives of the residents and how important cultural cohesion in the urban core can be.

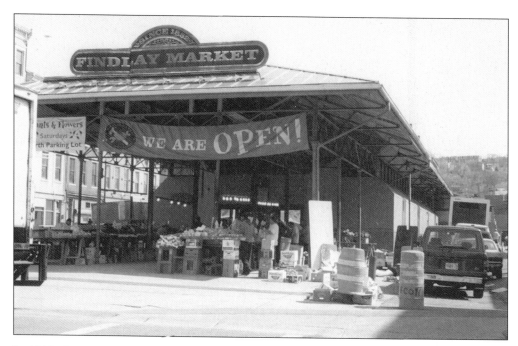

In 1833, General James Findlay purchased a large tract of land north of Liberty Street between Vine and Elm. The area came to be known as "Findlay's Woods," but was more popularly known as the "Northern Liberties," since it was north of what was then the city limits and beyond the reach of Cincinnati law enforcement. And, as legend has it, the denizens indeed exercised some liberties in their behavior. Findlay, a veteran of the War of 1812 and Cincinnati mayor, died in 1836 before his plans for a farmer's market on Elder Street were realized. In 1852, Findlay's heirs gave to the city the parcel of land on Elder between Race and Elm to be used for a market.

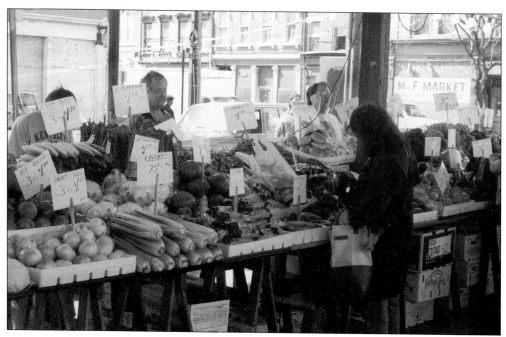

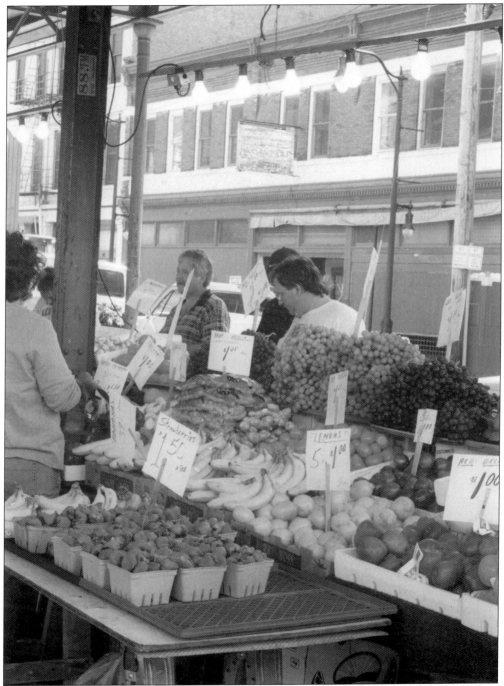

The first Findlay Market, completed in 1855, was little more than an open shed. Meat was hung on hooks and exposed to flies, soot, dust, and other unappetizing and unhealthy agents. The first remodeling didn't occur until 1902 when refrigeration was installed and the market was finally enclosed. Further updating took place in 1915. And in 1921, the Findlay Market merchants began one of the city's treasured traditions, the Opening Day parade that signals the beginning of the baseball season.

The decades from 1920 to 1970 saw the neighborhood's population steadily decline and become poorer. But Findlay Market survived, and in the late 1960s, it was selected by city officials to receive renovation funding through the Federal Model Cities Program. Completed in 1974, the project was an overwhelming success, and today Findlay Market continues to renovate and expand. Neighboring shops of longtime vendors offer meats, fish, bakery products, and other foods in addition to the fruit and vegetable stands. The Findlay Market neighborhood residents are decidedly poor and without viable transportation. The market is important to them not only as a source of fresh, healthy food, but of potential employment as well. That people from outside the neighborhood also rely on the market speaks to its importance in Cincinnati culture, as an urban place where people of various races and economic class can interact.

Findlay Market today is home to a group of colorful vendors dedicated to selling the freshest homegrown organic products. Gene Goldschmidt, variously known as the "Mustard King" and the "Horseradish King" was also the "Mardi Gras King" for the Market in 2003. Goldschmidt's stall features his own organic condiments, and his honey mustard was a gold medal winner at the 2002 Napa Valley Mustard Festival. Recently, there has been a grassroots movement for him to create a special hometown mustard for Great American Ballpark.

If there is an enduring symbol of the breadth of Over-the-Rhine's heritage, it is Old St. Mary's Church. Dedicated in 1842, it is the oldest standing church in Cincinnati. The church was built with bricks baked in the ovens of parishioners and entire trees hewed into beams by the men of the congregation. This glorious church completed a $425,000 renovation in 2003 that preserved its beautiful murals, plasterwork, sanctuary, and balcony. And holding to its German-American roots, Old St. Mary's still offers one Mass in German every week. More importantly, however, the church also holds to its guidance role in the neighborhood by offering practical social service programs to area residents.

NOTES FOR FURTHER READING

Cincinnatians are fortunate in that there has always been a group of historians and city enthusiasts who have documented its heritage in any number of ways and on a considerable variety of topics. However, Cincinnati is not an urban island; it also needs to be viewed in the context of other American cities. Two very good books are *Major Problems in American Urban History: Documents and Essays* (Lexington, MA, 1994), a book of readings edited by Howard P. Chudacoff, and another book by Chudacoff, *The Evolution of American Urban Society* (Englewood Cliffs, NJ, 1994).

Just a few of the excellent general histories of Cincinnati include John Clubbe's *Cincinnati Observed: Architecture and History* (Columbus, OH, 1992); *The Bicentennial Guide to Greater Cincinnati* by Geoffrey J. Giglierano and Deborah A. Overmyer (Cincinnati, 1988); the reprinted *WPA Guide to Cincinnati* (Cincinnati, 1987); Daniel Hurley's exceptional *Cincinnati: The Queen City* (Cincinnati, 1988); and *Cincinnati Then and Now* by Iola Silberstein (Cincinnati, 1982). Two books that are very important for learning about the political and economic development of Cincinnati are Zane Miller's *Boss Cox's Cincinnati: Urban Politics in the Progressive Era* (New York, NY, 1968) and *Workers on the Edge: Work, Leisure, and Politics in Industrializing Cincinnati, 1788–1980* by Steven J. Ross (New York, NY, 1985).

For Over-the-Rhine, important studies include *Changing Plans for America's Inner Cities: Cincinnati's Over-the-Rhine and Twentieth-Century Urbanism* by Zane L. Miller and Bruce Tucker (Columbus, OH, 1998). The book is an examination of the local and federal politics involved in governing and serving the neighborhood, particularly since World War II. It hasn't been received without criticism: some readers feel the authors take a pro-planning and development stance at the expense of advocacy for the poor. No matter what stance the reader takes, this book is a clear look at political and historical patterns in Over-the-Rhine. Another valuable study is *Over-the-Rhine: A Description and History* (Cincinnati, 1995), a set of guidelines for historic preservation coordinated by the Cincinnati City Planning Department.

Also of use are Robert Wimberg's books, *Cincinnati: Over-the-Rhine* and *Cincinnati Breweries* (published in Cincinnati in 1987 and 1989, respectively) that are excellent checklists of neighborhood buildings. Of considerable value are Charles Ludwig's *Playmates of the Towpath*

(Cincinnati, 1929), Don Heinrich Tolzmann's *German Heritage Guide to the Greater Cincinnati Area* (Milford, OH, 2003), and Timothy J. Holian's 2-volume history, *Over the Barrel: The Brewing and Beer Culture of Cincinnati* (St. Joseph, MO, 2000 and 2001). It is encyclopedic in scope and adds a great deal to the history of Cincinnati Germans and Over-the-Rhine.

For the music heritage of Over-the-Rhine, see B.J. Foreman's *CCM 125: College-Conservatory of Music, 1867–1992* (Cincinnati, 1992), and for transportation, *Cincinnati Streetcars: No. 2, The Inclines* by Richard M. Wagner and Roy J. Wright (Cincinnati, 1968). Also related to the transportation issue, we relied on the massive collection of original material on the Rapid Transit Commission and the ill-fated subway system held in the Archives & Rare Books Department at the University of Cincinnati.

Of great interest is Sanford Zilberberg's article, "The Ohio Valley Exposition," in *The Numismatist*, Vol. 97, No. 8 (August 1984). For Findlay Market, see Fr. Aloysis Schweitzer's *The History and the Story of Findlay Market and the Over-the-Rhine Community Center* (Cincinnati, 1974) and a study by the Economics Research Group in the Center for Economic Education at the University of Cincinnati, *The Findlay Market District: A Comparative Demographic Analysis* (Cincinnati, 2002).

And for excellent examination of Cincinnati's urban Appalachians, see Dan McKee's *From Mountain to Metropolis: Urban Appalachians in Ohio* (Cincinnati, 1978), Thomas E. Wagner and Phillip J. Obermiller's *Valuing Our Past, Creating Our Future: The Founding of the Appalachian Council* (Berea, KY, 1999), *Appalachian Odyssey: Historical Perspectives on the Great Migration*, ed. by Obermiller, Wagner, and E. Bruce Tucker (Westport, CT, 2000), Kathy Kahn's *Hillbilly Women* (Garden City, NY, 1973), and, of course, Roscoe Giffin's *Report of a Workshop on the Southern Mountaineer in Cincinnati* (Cincinnati, 1954).